IMAGE AND SPIRIT

IMAGE AND SPIRIT

FINDING MEANING
IN VISUAL ART
KAREN STONE

Augsburg Books
MINNEAPOLIS

For Howard

IMAGE AND SPIRIT
Finding Meaning in Visual Art

Copyright © 2003 Karen Stone. All rights reserved. Except for brief quotations in critical articles or reviews, no part of this book may be reproduced in any manner without prior written permission from the publisher. Write to: Permissions, Augsburg Fortress, Box 1209, Minneapolis, MN 55440.

Large-quantity purchases or custom editions of this book are available at a discount from the publisher. For more information, contact the sales department at Augsburg Fortress, Publishers, 1-800-328-4648, or write to: Sales Director, Augsburg Fortress, Publishers, P.O. Box 1209, Minneapolis, MN 55440-1209.

The quotation on page 59 is from an interview with Sister Wendy Beckett as posted on the Web site of the Public Broadcasting Service. Copyright © Sister Wendy Beckett. Used by permission.

The quotation on page 114 is from "The Wasteland" by T.S. Eliot, in *Complete Poems, 1909-1962* (London: Faber and Faber Ltd), p. 53. Used by permission.

Scripture quotations are from the New Revised Standard Version Bible, copyright © 1989 by the Division of Christian Education of the National Council of Churches of Christ in the USA and used by permission.

ISBN 0-8066-4550-4

Cover design by Sarah Gioe; cover art from Art Resource: James Abbott McNeill Whistler (1834–1903), *Nocturne: The Silent Sea,* 1866. Oil on canvas. Gilcrease Museum, Tulsa, Oklahoma; Book design by Michelle L. N. Cook

The paper used in this publication meets the minimum requirements of American National Standard for Information Sciences—Permanence of Paper for Printed Library Materials, ANSI Z329.48-1984. ♾ ™

Manufactured in Canada.

07 06 05 04 03 1 2 3 4 5 6 7 8 9 10

Contents

111290

Illustrations

1. Michael Tracy. *Cruz de la Paz Sagrada (Cross of the Sacred Peace),* 1980, installation view from Chapel, 1981. Wood, rayon cloth, acrylic, hair, nine swords, crown of thorns (cactus, string), tin and bronze milagros, and oil paint, 72 in. x 48 in. x 36 in. The Menil Collection, Houston. Photograph courtesy of the artist.

2. Mark Rothko. *The Rothko Chapel,* interior, 1971. Copyright © Kate Rothko Prizel & Christopher Rothko/Artists Rights Society (ARS), New York. Photograph copyright © Hickey-Robertson, Houston, courtesy of The Rothko Chapel.

3. Clyde Connell. *Song from Bistineau,* 1979. Brown paper, rice paper, mulberry paper, graphite, charcoal, 101 in. x 66 in. Collection of Bryan Connell. Photograph by Martin Vandiver, Dallas. Used by permission of the Connell estate.

4. Karen Stone. *B. P. (After Jackson Pollock),* 2001. Mixed media on paper, 10 in. x 17 in. Courtesy of the artist.

5. Diego Rodriguez de Silva y Velazquez. *Las Meninas (The Maids of Honor),* 1656. Museo del Prado, Madrid. Alinari/Art Resource, New York. Photograph copyright © Erich Lessing/Art Resource, New York.

6. Vincent van Gogh. *Potato Eaters,* 1885. Lithograph, 21.5 cm x 31.4 cm. The Museum of Modern Art, New York. Gift of Mr. and Mrs. A. A. Rosen. Photograph copyright © 1999 The Museum of Modern Art, New York.

7. Pablo Picasso. *Guernica,* 1937. Mural, approx. 11 feet 6 in. x 25 feet 8 in. Museo del Prado, Madrid. Photograph copyright © Snark/Art Resource, New York. Copyright © 2002 Estate of Pablo Picasso/Artists Rights Society (ARS), New York.

8. Francisco Jose de Goya y Lucientes. *Los Ensaches (The Men in Sacks)*, from Los Proverbios series, published posthumously in 1864. Etching, 248 mm. x 359 mm. Collection of the author.

9. Max Beckmann. *Family Picture*, 1920. Oil on canvas, 65.1 cm x 100.9 cm. The Museum of Modern Art, New York. Gift of Abby Aldrich Rockefeller. Copyright © 1999 Artists Rights Society (ARS), New York/VG Bild-Kunst, Bonn. Photograph copyright © The Museum of Modern Art, New York.

10. Karen Stone. *Chalice,* 1998. Black and white photograph, 8 in. x 10 in. Courtesy of the artist.

11. Magdalena Abakanowicz. *Backs,* 1976-1982. Burlap and resin, 80 pieces (each unique), each approx. 69 cm x 56 cm x 66 cm. Copyright © Magdalena Abakanowicz, courtesy Marlborough Gallery, New York.

12. Anselm Kiefer. *Quaternity,* 1973. Oil and charcoal on burlap, 118 1/8 in. x 171 1/4 in. Collection of the Modern Art Museum of Fort Worth. Museum purchase, The Friends of Art Endowment Fund.

13. Albert Pinkham Ryder. *The Race Track (Death on a Pale Horse),* 1910. Oil on canvas, 70.5 cm x 90 cm. Coyright © The Cleveland Museum of Art. Purchase from the J. H. Wade Fund (1928.8). Photograph copyright © Francis G. Mayer/Corbis.

14. A color wheel.

Foreword

Religion and art are both affairs of the human imagination. To imagine with increasing clarity our selves, our relationships, and the world as a whole as God intends them to be is at the heart of the spiritual quest. To imagine with increasing clarity how particular visual images relate to the deepest realities of life is at the heart of the artistic quest. The intersection of these two kinds of imagination, these two quests, is a matter of crucial importance to all those, both artists and spiritual searchers, who wish to move more deeply into the freedom of expression that is the natural aspiration of each.

Somehow, however, most books about the relationship between art and religion tend to limit rather than to expand that freedom. In the first instance, many authors suggest that in order to have a religious encounter with a work of art, the work itself has to be explicitly religious in its intention and subject matter. Then we are told "what to look for" in a religious painting or sculpture and how to ferret out the artist's "original intentions." Scholars explain the "real purpose" of the use of form, light, and iconography so that we might better understand the piece of art as an objective reality. It is generally presumed, of course, that this kind of intellectual understanding of what a piece of art "means" is a necessary prerequisite for any kind of valid encounter. As a consequence, many ordinary readers find their religious imaginations increasingly confined within rather narrow interpretative boundaries.

Worse still, this approach sends the subtle message that the viewer cannot be trusted. It suggests that the relationship between spiritual searcher and a work of art is a monologue, rather than a dialogue: art is a teacher, a "guru," rather than a conversation-partner. Of course no one wants to do anything to advance the "I-

don't-know-much-about-art-but-I-know-what-I-like" school of appreciation. But its opposite ("I-know-a-lot-about-art-but-I-don't-have-the-first-idea-what-I-like") is perhaps more danger-ous still, and it is this attitude that is often encouraged by those who see art as having pre-determined religious messages to be inscribed on the blank slate of the viewer's religious imagination.

As a result of this approach, many in the past half-century have become quite pessimistic about the future of art as an effec-tive catalyst for deepening the human relationship with God. They are eloquently represented by the French philosopher Simone Weil, who writes out of a passionate interest in both the state of the human soul and the state of human creativity. Weil's concern about the continued spiritual potency of the "visual Word" does not arise from a conviction that the artistic impulse will go dry among Christian believers, nor from a sense that there will be a dramatic disagreement about basic thematic con-ventions. It is the stability of the deeper foundations of art that troubles her. "Art has no immediate future," she writes, "because all art is collective, and there is no more collective life (there is only dead collections of people) and also because of the breaking of the true pact between body and soul."[1]

We begin to share Weil's anxieties when we notice how often these two essential aspects (the communal and the sacramental) of the dialogical relationship between spirituality and art are neg-lected. To understand that the spiritual searching of viewer and artist alike is set within a community of searching, a community with a past, a present, and a future, is one essential ingredient to a vital conversation between art and the devotional life. Equally important is the need to see the potential for divine encounter within the art-artist-viewer relationship, to see at the conver-gence point between art and human aspiration endless possibili-ties for the mystery of transformation to occur. If either of these perspectives is ignored or forgotten, the danger remains high that arts will lead us into forms of spirituality that are both isolated and impotent.

As an artist, art educator, and scholar of religious experience, Karen Stone offers a unique perspective on this complex web of relationships between art and spirituality. Written against the backdrop of traditional art interpretation, and with a clear sense of both its difficulties and advantages, *Image and Spirit* is always clear that each person who seeks spiritual nourishment from art bears a responsibility for active engagement, for persistent perceiving, as well as for weaving any response to a work of art into the overall fabric of the spiritual life. From that foundation of confidence in the viewer's own ability to perceive and integrate, Stone begins to talk about art and the religious life in a way that encourages artist and viewer to become full and equal partners in the making of meaning. It is certainly true that those who wish to enter this partnership must acquire certain skills, competencies, and attitudes, and this book is ingenious in helping us to acquire them, but it avoids strapping us into an interpretative straightjacket as it does so.

The spiritual life of the faithful Christian is never formed in isolation from others, and in the pages of this book we are also given a sense of the profound significance of art in the church's common life. We are invited to put away any lingering sense that the liturgical arts are simply secondary devotional aids or examples of some particular religious aesthetic, and to begin to appreciate the role they play in the essential formation of the worshiping community. Just as we grow together as fellowship of interpretation around the words of Scripture and around particular denominational histories, in the same way we can learn to grow together as fellowship of interpretation around the arts that serve the worship of the church. It is not that we will always agree on what we are seeing, but we will share with one another the experience of communing with images, the experience of the struggle to express our responses to images, the experience of deeply desiring an ever more visible Word.

The ultimate goal of this book, of course, is the expansion of human insight, both spiritual and visual. If we allow *Image and*

Spirit to guide us, we will surely make a significant step in the journey toward a deeper relationship with the God of creativity, imagination, and joy.

Susan J. White
Brite Divinity School

Preface

What do you expect from art?

Should it enlighten you? Move you? Stimulate your intellect? Please your senses?

Should art spark a moment of recognition, a memory perhaps, or a sudden understanding of something that was hidden inside you?

Over the years I have asked a great many people what they expect from visual art. Their answers are remarkably consistent. People expect art to decorate their environment, soothe or entertain them, resemble someone or something, remind them of a place or a story, communicate ideas, stir their emotions. But the most-recurring thing I hear people say they expect from art is that it provide some understanding, some insight, some connection with the world of spirit. To be sure, they phrase it in various ways, but the word "meaning" surfaces again and again. "What does it mean?" is the number-one question people ask about an artwork; "It's meaningless" is their most frequent criticism.

Many are confounded when they look at visual art that seems like a foreign language, its content unintelligible to them. They react with strong emotions—the more dogmatic of them with indignation, the more open with bemusement.

A few years ago I spoke with a woman who had taken at least seven European art tours led by various professors. She exclaimed how wonderful it is to travel with someone "so knowledgeable about art, so insightful." This woman went on to say of a particular tour leader, "When he interprets a painting for us, I marvel at what he can see. He just opens it up for me. I would never be able to find all those things in a painting."

No doubt her life is richer for these experiences. But one thing struck me as sad: After seven years of rather intensive study and travel, my friend had not a clue about how to describe and interpret these artworks for herself, how to respond to them on her own, how to discern in them some deeper meaning.

It seems to me that there has been an unspoken conspiracy among the "In Group" of the art world to hold onto their positions as experts, interpreters, keepers of the keys to these locked mysteries. (Tom Wolfe addressed this issue in *The Painted Word*).[1] I am embarrassed to recall conversations I have heard, and even joined into, that ridiculed the ignorance of other people when it comes to art. Assuming a patronizing attitude does nothing to enhance people's experience of art. It does little to promote an interest in art. It does much to widen the chasm between the artist and the public.

This book is addressed to the many who are frustrated at their first (or hundredth) encounter with a work of visual art that seems inscrutable or even meaningless, but who want to be less confused to open up art's meaning and even to find in it the Spirit's voice.

Image and Spirit—obviously—is not a seven-pound coffee table book (more about that in the How to Use This Book section). I have assumed a passing acquaintance with some of the major artists and periods of art on the reader's part, but anyone with an illustrated volume or two of art history and reasonable proximity to art museums and galleries will find it easy and enjoyable to fill in whatever images they cannot bring to mind.

The author presupposes that there is nothing inherent in a work of art to forbid its interpretation on a spiritual level—indeed, on any level—and that in the apprehension of meaning the viewer's role is of equal importance with the artist's. The book's emphasis is not upon explicitly religious art, but rather on developing an ability to look at and interpret spiritual meaning in art of any style and period.

Most of what is written, especially in Part One, could be applied as well to literature, dance, music, theater, film. But the book does not deal with all of the fine arts, except in passing. Visual art is my background, and I have chosen to limit the discussion to that.

I also have chosen not to address the issue of censorship or with art's potential as a force for evil. (The latter is a complex, potentially controversial, and enormously fascinating subject that exceeds the scope of the present project.)

The book, while granting the significance of the effects of culture, race, and gender upon art, focuses primarily upon works of art as they exist in the viewer's present. Indeed, I hold that visual art has for viewers a certain timelessness that can transcend its original context.

Finally, this is not a treatise on religious aesthetics or a definitive work on art criticism for professionals. The audience for *Image and Spirit* is people of faith from all walks of life, both lay and clergy, who share an active interest in art and a desire for help in interpreting it. Although a background in art is not necessary to an understanding of the book's contents, I entertain the hope that artists will find it helpful in their spiritual quest.

Part One of *Image and Spirit* gives a theological and aesthetic background for a view of art as visible Word—as embodiment of the transcendent. Chapter 1 explores the pervasive role of images in our physical and spiritual existence, the concept of the visible Word as it might relate to art, and the role of viewer and artist alike in art's spiritual apprehension.

Chapter 2 examines the tension between matter and spirit that characterizes human life, and the dangers of tending one part of our nature to the neglect of the other. Meaningful symbols are needed, which involve us as integral physical and spiritual beings; art may serve as one of these symbols, and as such can be considered practical theology.

Chapter 3 proposes a working definition of art and examines various purposes for art through the ages, here suggesting

the importance of culture upon the objects and images we now call art.

Part Two of the book offers specific tools for interpretation that allow art to break through the surfaces of our experience and reveal even as it deepens mystery. Chapter 4 sketches a theoretical base for a way of looking at art that uses what is known about systems of critical thinking, yet acknowledges our primitive responses as we approach a work of art. It incorporates elements of linear and phenomenological approaches to art criticism—heeding the questions many raise about the validity of over-analyzing works of art. It stresses the need for flexibility (perhaps even a kind of focused disorder) in interpreting art's depth.

Chapter 5 presents a way to see, think, and speak about art that takes advantage of our natural cycles of perception and response. The process begins with the need to enjoy art and understand its spiritual depth, with openness, with a willingness to wait, with just due given to one's spontaneous responses, and with disciplined looking.

The stage is set for a more detailed analysis of art's form in chapter 6. This is the nitty-gritty core of this book. It includes a brief explanation of the basic elements of art, followed by discussion of six pairs of formal criteria for analysis that in my experience lend themselves to a spiritual understanding of art.

Though interpretation has been an implicit part of the method presented in the two previous chapters, chapter 7 looks specifically at ways in which the process of interpreting art is similar to the process of making art, giving some attention to the matter of judgment and finally coming, full circle, back to response.

In Part Three the book moves from the private to the communal experience of visual art. Chapter 8 examines ways in which visual art can be not only a visible Word but also a prophetic Word, raising its image-voice against injustice and greed; rousing action and arousing emotions; facing death squarely; and enabling us to imagine and form an alternative to the ruling order within ourselves and in our world.

Chapter 9 addresses art's unifying role. It shows ways in which art is made and experienced communally, and includes concrete ways in which art can enrich the shared spiritual and aesthetic journey of a community of believers. Art as the Spirit's voice is a contagion.

Writing the book has been such a journey for me, a contagious experience that has infiltrated every area of my life. It began, I suppose, when I started to notice that as an artist and a believer I live in two worlds that seem to have little to do with each other. One foot is in the art world—studio, gallery, classroom, museum—while the other foot is in a community of believers, in theological discussions and reading, in my own spiritual life.

Many of my acquaintances in one sphere have little knowledge or understanding of the other. In the world of faith, art is widely misunderstood. Artworks found in churches often are either very old or trite. Many books written about art from a theological perspective focus on specifically (even self-consciously) religious works. Meanwhile, in the art world, religion seems similarly misunderstood. It is as if some artists and art professionals froze their twelve-year-old impressions of religious faith, having only media stereotypes of religion to provide more recent input. There are many exceptions, of course. Still, at times I feel as if I am doing the splits!

Slowly my own perceptions of the whole, the mystery of existence, the movements of the Spirit, began taking visible form in my artworks. As director of the art gallery at a church-related university, I had the opportunity to mount a few exhibits with themes that gave expression to these sensibilities through various artists' eyes and hands. And thus I began to do something about "the splits," about the dissonance between my two worlds.

Then I was asked by a church to meet with their architects and design artworks such as stained glass, banners and hangings, robes, and sculpture for a new sanctuary. The experience crystallized my thinking about the role art can and should play in a life

of faith (see especially chapter 9). Shortly afterward I left for a stay at Westcott House, the Anglican theological college in Cambridge, England. There I began reading about theology and art, the philosophy of art, religious and aesthetics and liturgies, as well as art criticism and art history. I determined to write a book on liturgical art, and I began.

But the direction of the book changed when I returned home and began teaching art history along with studio art. I am, after all, an art educator. The practical challenge of teaching students how to look at and interpret art, which must be an integral part of any meaningful study of art history, led me to see the project in its present form (and back to Cambridge for further study).

Many people deserve thanks as this project reaches fruition. I am deeply appreciative of those who read the manuscript and shared their valuable insights: Robert Benne, Frank Burch Brown, James Duke, Elizabeth Gjelten, Mark Thistlethwaite, Susan White. In particular I would like to acknowledge Burch Brown for his influence on my ideas about definitions of art (chapter 3) and Walter Brueggemann, with whom I share four wonderful friends, whose work was a major source of inspiration for chapter 8, Art As Prophetic Word. All of these people helped me develop my own thinking and put it in a form that others could use.

I am indebted to my students for challenging me, for the wonderful essays they write about art, for their enthusiasm, their keen observations, and honest questions.

I thank Westcott House for the little study in D Staircase with slanting white walls and a view of the courtyard, occasions to worship and exchange ideas, chances to let the sounds and sights of evensong at King's College wash over me when all my words had congealed into porridge.

Last, first, in between, and on into the future, I remain grateful to Howard Stone for believing in me, for putting up with me when I agonized over the project's ups and downs, and even for goading me. He read the manuscript several times over and was my honest—and loving—critic.

How to Use This Book

This is a handbook, not a picture book. Put it in your purse or jacket before visiting an art exhibit or museum. Keep an extra copy in the car. Take it with you to Italy.

Do, however, amass all the art picture books that you can get your hands on—new, used, remaindered, scruffy, or clean. (See Further Reading and Resources.) Keep them near at hand, perhaps open on the table, while you are reading this book. Interrupt your reading often to look at pictures of art. Search for relationships. Locate artworks in your picture books that confound or perplex or astound, and then apply the principles found in these pages to those difficult images. Look at examples of artwork you particularly like, and see what new layers of meaning you can find in them.

Make a decision: try to be as open as you can be, to trust your instincts but not hold on to your first reactions too tightly. Loosen your grip on your opinions.

Read the book any way you like—all the way through, a chapter at a time, a page at a time. It's okay to know how the book ends before you read the middle.

Write in it (if it belongs to you), mark it up, and highlight it.

Whenever you can, seize the opportunity to see actual artworks. (Refer especially to Part Two.) Note how your response to the work changes when you stand in front of the original. This is not only a matter of accurate color and texture, but of presence; looking at a tiny reproduction of Picasso's *Guernica,* for instance, cannot compare with standing in front of the commanding, wall-sized original.

Stop as you read and do the exercises suggested. Don't say to yourself, "That's a good idea—I'll try it later." Write, draw, say, or make as you read.

Remember that the task of interpreting and responding to art is never a straight line. It is closer to a tangle (see chapter 4). Flip back and forth in the book. What you read in one chapter may make you think of a phrase in another or an artwork you

saw in another book. Go back, or find that other book, and jot down some notes about the relationship you observed.

Store memories of artworks to retrieve while you are reading. What images does this or that paragraph bring to your mind's eye?

Take the suggestion of keeping a journal for your reflections on art; use it also to record thoughts that come into your mind as you read. Have a little dialogue with the author—where you agree, where you disagree.

When the book is used for group study and exploration, it is important that the leader function as facilitator rather than expert. Every person has valuable knowledge that will enrich the group's journey toward greater understanding of art's spiritual import.

Above all, wait. Give these words time to settle and jell, to connect with your own memories and experiences. Sitting or standing in front of an image—especially one that is difficult or troubling—wait, and then wait some more. Allow the art to work on you. Wait, and listen for the Spirit's voice.

Part One
Art As
Visible
Word

One

Sight and Spirit

For art to me is an anecdote of the spirit, and the only means of making concrete the purpose of its varied quickness and stillness.
—Mark Rothko[1]

"I see."

Meaning: I know, I understand, I believe.

Sight is a cardinal metaphor for understanding, for we are a race of image-makers. However deeply images may lie buried under the weighty rubble of words and thoughts, they are a fundamental structure of awareness. Words communicate our experiences and ideas, but images *form* them.

With their visual weight, images have a power to affect and convince that words cannot carry. As an example I offer my own impressions of an artwork that I saw twenty years ago at the San Antonio Museum of Art. The exhibit, titled *Off the Wall,* was made up of sculptural installations and environments that, as the title implied, did more than hang on a wall or sit on a pedestal. In it Michael Tracy, then a young artist from Texas, had created *Chapel.*

Fourteen simple wood and silver leaf stations of the cross lined the dark walls of the enclosure. Viewers were forced by an offset entrance to walk into the space completely in order to see it at all. Once our eyes adjusted to the candlelit semidarkness, we discovered ourselves standing among altar-like sculptures reminiscent of *ofrendas*—displays of objects that might typically be laid out on a tabletop in a Mexican home for the Feast of All Souls (in Spanish *El Dia de los Muertos* or The Day of the Dead, a religious and cultural feast day). Materials such as wood, cloth, hair, swords, oil paint, blood, rope, and iron spikes were clustered and impaled together in crowded assemblages.

The experience of this work of art was unsettling. One had a sense of being brought to the possibility of profound religious experience. Inadequate words came to mind—dread, fear of death, dark night of the soul—but also an appreciable undercurrent of strength and hopefulness transmitted through this particular visual interpretation of a rural Central American tradition that blends Roman Catholicism with indigenous religion, folklore, and mysticism. It spoke to me of spiritual as well as physical suffering, of courage and survival.

Even after two decades it is relatively easy for me to bring an image of Tracy's *Chapel* to my mind's eye. To recall his written statement, printed on the wall at the entrance to the installation, required that I track down a copy of the text. The artist dedicated this work to his "brothers and sisters trapped in the tragic agony of El Salvador. What is happening to them as their heads are cut off, their feet beaten, and their bones smashed is also mystically happening to all of us. Our government supports the cause of their dark and constant pain."[2] *Chapel* was not meant to be a religious statement but, in part, a blow against the church's collusion with the ruling class, with those who enforce and profit from torture and oppression (see chapter 8, Art As Prophetic Word).

The artwork, and the artist's statement, was clearly political in intent. Yet Tracy's art, and in one sense even his words, transcended politics. In writing that the Roman Catholic Church

administers the sacrament to a right-wing American general as well as to El Salvador guerrillas struggling to overthrow the military junta, he evinced more than his objection to the church's dissemination of the eucharistic gift. Beneath the polemics, he demonstrated an elemental grasp of the sacrament's significance and power.

Had the artist set out to sentimentalize religious experience, to idealize or even convert, who would have noticed? For this artist the presence of God is not a pretty sight. It is sublime—frightening, mysterious, out of our control. To him, perhaps, Jesus is much the same Jesus as he was to Hazel Motes of Flannery O'Connor's short novel *Wise Blood*—a ragged, shadowy figure darting from tree to tree in the back of his mind. Perhaps, as O'Connor later wrote about Hazel Motes, this artist's apparent verbal attempts to deny and banish that ragged figure are less important than his inability to succeed.[3] Indeed, even Tracy's most politically and sexually charged artworks and performances embrace and transform such traditional religious imagery as stations of the cross, icons, altars, *retablos,* and the like. Whatever Tracy's personal religious belief and practice, one can assume that it is inextricably bound to his passion for social justice.

As an introduction to the discussion of a spiritual interpretation of visual art, the present chapter will explore the pervasive role of images in our physical and spiritual existence, the concept of the visible Word as it might apply to art, and the role of viewer and artist alike in art's spiritual apprehension.

The Power of Images

Every aspect of life is composed or defined or affected by images. *Image* is used here in the broadest sense. It includes more than a reproduced sight, more than a memory or impression or mental conjuring up of some sight. Images embrace whatever can be apprehended by the senses. Thus music is experienced as image, as is dance, ritual, poetry, drama.

Just as visual images may carry sounds and smells (low-flying airplanes, bombs exploding, people screaming, sharp scent of gunpowder, smell of burning buildings in Picasso's famous painting *Guernica*), touch (erotic art, with the capacity to make one's flesh tingle) and taste (what mouth does not water at an expertly filmed fast food commercial?)—so the arts of all our senses can evoke visual images. Even music, which requires no sight and may be heard best in darkness, brings images to our minds: if not remembered sights, then colors or textures, darks and lights. It may be that we have, at our center, a "will to image" that explains the apparent universality of art-making—of sensory and sensual creativity—in human history.

Words Fail Me

Often *sight* and *touch* submit to verbal description: good novelists can summon a scene to the reader's mind. But try to explain the quality of red to a color-blind person and you will find how we depend on a shared understanding of visual references for such descriptions to communicate.

Sound also can be explained, to a point, for spoken words are symbolic noises; words like crash, thud, slam, purr, whine, shrill, and whisper get their meaning across. But music of any complexity—a concerto, for example—is difficult to verbalize.

Beyond a few basic categories like salty or acrid, *taste* and *smell* are indescribable except through similes, and the images those similes call forth are determined by our past experiences. The flavor of a Bosc pear brings to my mind the market in Cambridge, England, where we used to buy an exotic tropical pear that tasted distinctly like coconuts. The aroma of freshly ground coffee triggers my imagining of vague and deeply pleasing composite scenes—morning sunlight, the lake view and pine walls of my summer studio where a steaming mug sits ready at my elbow, a quick strong cappuccino between trains in an Italian *stazione*, small town cafes, a brief civilizing pause in a hectic day.

In our experience as humans there are sensory memories, elusive truths that seem unknowable or that we know but cannot express with language: emotions, rhythms, sensations, longings—all images. Artists always have used images to bridge the gap between what is objectively known and what is felt.

Made in the Image

Images shape our expectations, our ideas about ourselves, our judgments of people, places, and things.

Some choose a bank because of its solid and dependable image, buy a car because they hope its image will reflect their importance. Dress for success. Vote according to the image projected by a candidate or, as candidates, hire image makers to fashion an electable persona. Even though such images actually are concepts, they rely heavily upon the visual for their formation and apprehension.

A Picture's Worth a Thousand Words

Even our language revolves around images. Try passing an hour in conversation without their benefit. You may find that you seldom utter three or four consecutive sentences without using a metaphor, and metaphors rely on images rather than literal description to communicate the essence of an idea or a thing—so much so that in some cases they are hard to translate adequately:

You're a brick. (*You are reliable.*)

Kenneth is a pussycat. (*He is kind and gentle.*)

It was raining cats and dogs. (*Three-point-two inches fell in less than an hour.*)

Andy is a couch potato. (*He avoids exercise.*)

Don't spill the beans. (*Don't tell.*)

Clean sweep, on the rocks, nerves of steel, eye-opener, food for thought, fragile economy, kid gloves, ruffled feathers.

Smooth operator, backstabber, heartbreaker, strange bedfellow. Housewarming, blacklist, rubber match, balloon payment, may I have the floor, eat crow, good as gold.

It's All Greek to Me

Remember the story of the Tower of Babel? After the builders of that biblical high rise were struck with a host of different tongues, their ability to understand each other vanished and along with it their grandiose schemes. One person's language became the next person's babble.

Language itself is made up of signs—marks and sounds—that stand for specific things but have no inherent meanings of their own. To anyone uninitiated into the system of meanings assigned to a particular language, it is unintelligible. Unused, it is quickly forgotten.

Images Convey Meaning

. . . and they do so across barriers of language. The shapes and configurations of the letters that spell *hand* or the sound of the word as it is pronounced communicates only to those familiar with the English language. A picture of a hand, of course, is universally understood along with its attendant significance (creating, guiding, chastising, pointing, caressing, giving, receiving, holding, stopping, comforting, hiding, shaping, healing). People who seem to be worlds apart socially, culturally, educationally, racially, religiously, who do not even speak the same language, can share their common experience through images. Even our mutually understood words come alive for us only when they summon memories that we can imagine in our mind's eye.

Images Form and Inform Belief

Throughout history and prehistory the universal language that human beings have used to respond to God and to address the spiritual dimensions of their lives has been the language of image. When people worship, for example, they absorb and integrate and create images (see chapter 9.) Even the great themes of faith—creation, sin, redemption, incarnation, justification—are revealed through images so potent and durable that people find it virtually impossible to separate the underlying meaning from the symbol.

The Visible Word

> In the beginning was the Word, and the Word was with God,
> and the Word was God. He was in the beginning with God.
> All things came into being through him, and without him not
> one thing came into being. (John 1:1-3)

In this passage from John there is one, unified Word. That Word is not language, though the gospel writer uses language to impart its meaning. The Word (*Logos*) in which the Spirit is revealed must be *embodied*, writes Robert Jenson; must have "some visible reality . . . we must be able to see and touch what we are to apprehend."[4]

Visible and Accessible Word

In varying degrees every religion embraces ritual and symbol—images that tell more compellingly than historical fact or dogma of the unapproachable, the unintelligible, the mystery of our existence. "The Word comes to the element; and so there is a sacrament, that is, a sort of visible Word."[5] Augustine's memorable lines describing sacrament have been interpreted and reinterpreted throughout the centuries, but one theme has remained constant: God is present, is manifested through some form of visible reality. In spite of his lifelong uneasiness with the physical world, Augustine held that the sacramental elements (all of which are physical images) are a way of securing the Word in our sensory world and thus making it accessible to us.

Visible and Sensory Word

While Augustine and most of his early interpreters contrasted the visible with the invisible Word, reformers such as Luther shifted the emphasis to the visible as opposed to the verbal Word, or language. In this understanding of visible Word, God reaches us not only in language's abstract signs, but also in those images and symbols that are comprehended physically by the senses. It affirms the validity of the physical image as embodiment of spiritual reality.

This distinction between the verbal and the sensory will advance the clarification of art as disclosive Word for two reasons. One, in every instance of effective communication, some things need to be put into phrases and sentences (verbal Word) and some are transmitted to the senses through gestures, rhythms, light, shapes, color, texture, and the like (visible Word).

Second but perhaps more important, the work of art is itself a Word, an embodiment (see chapter 2). It exists apart from its maker and culture and from any point the artist may have been making. It's a thing not to be decoded, but experienced. This is not to say that a work of art is a sacrament; of course it is not. Yet it may function sacramentally, in Augustine's sense of the sacramental, to the degree that it makes visible even a small glimmer of the other—the unseeable and yet sensed, the unknowable and yet longed for: the mystery.

Enduring Visions

Frequently images survive in our memory long after words are forgotten. It is in the lasting images of the visible Word that the Spirit meets us with its unchangeableness. Its forms are many; here I will expand Augustine's and the reformers' understandings of visible Word to include such things as prehistoric fertility figures, Jeremiah's visions, Greek icons, a Bach cantata, roadside shrines, a tribal dance, Gothic cathedrals, a simple hymn. Michelangelo's *Pieta*, Picasso's *Guernica*, van Gogh's *Starry Night*, Barnett Newman's *Broken Obelisk*. The word-pictures of the poet William Carlos Williams or the Psalms. A jazz improvisation. A film, *Tender Mercies* or *The African Queen*. Jackson Pollock's tangled interlace. Ladysmith Black Mambazo. Pete Fountain playing "Just a Closer Walk with Thee." The moving but overlooked works of countless unknown artists.

The Image of God

The ultimate image in the Christian faith is the person of Jesus: the embodiment of the invisible, God's physical presence among

us. God is wholly other and inaccessible to us; but through the incarnation of the Word in Jesus, God becomes a physical presence. Likewise in gestures, rites, and other elements of the sensory sphere, the hidden is revealed and the truth is experienced in ways we can apprehend. To quote Luther,

> God . . . sets before us no word or commandment without including with it something material and outward, and proffering it to us. To Abraham he gave the word including with it his son Isaac. To Saul he gave the word including with it the slaying of the Amalekites. To Noah he gave the word including with it the rainbow. And so on. You find no word of God in the entire scriptures in which something material and outward is not contained and presented.[6]

The Image-Language of the Spirit

God reaches us through language's abstract signs but also—and perhaps more completely—in *images* that are grasped by the senses, are seen, touched, smelled, heard, tasted. It is the acting out of the Word, its proclamation through art and music and pageant and water and bread and wine. Words or phrases about depth, or mystery, or Spirit, cannot fully convey what they mean until they become a perceivable presence.

Depth: The Dimension of Art

Art at its best makes concrete what language and especially religious language cannot: that intangible, private or communal moment when we encounter being. It does so in a way that is broader than specific religious images and rituals, encompassing every conceivable arena of human experience, and at the same time narrower, more intimate and personal as artist and viewer reflect on their individual perceptions of the Word through images.

Depth

The very intangibility of these moments may be understood through the image of *depth*. Paul Tillich's ideas concerning depth as a metaphor for the spiritual dimensions of life have continuing usefulness in our search for a definition of the spiritual in art that is limited enough still to define, yet open enough to allow as many people as possible to enter into the discussion. The depth of time (as opposed to length), the depth of truth (as opposed to surface appearances), the depth of suffering (as opposed to height), and deep joy (as opposed to fleeting pleasures) are all dimensions to which art reaches.

Spirit/Spiritual/Spirituality

In contemporary usage, *spiritual* is a term that has a broad array of meanings—psychological, mystical, otherworldly, or even referent to some vague supreme power such as "The Source" of intergalactic fantasy. In these pages *spiritual* will be used to describe the depth dimension: that is, the ontological, the essence of experience beneath and beyond the surface appearance of things.

The word *Spirit*, on the other hand, has a personal character. It is one of many ways of identifying transcendent reality (see chapter 2). The Spirit is beyond our knowing, yet makes God known to us.

Spiritual life or *spirituality* further implies a relationship. Geoffrey Wainwright describes spirituality as "an existence before God and amid the created world. . . . It is the human spirit being grasped, sustained, and transformed by the Holy Spirit."[7] Active involvement in a relationship, and a degree of intensity, are implicit in any understanding of spirituality.

Artworks that are spiritual in their essence are not concerned with answers, at least not with answers that have been institutionally established, notes Edmund Burke Feldman. They are, rather, engaged in a "search for ultimate values through the use of visual form."[8] Many times it is impossible

even to identify and label that search, but artists throughout history have expressed it by breaking through the surfaces of things, by reaching for the depths.

Art's Spiritual Voice: The Viewer's Role

Some might find it presumptuous to impose on art a spiritual interpretation that reaches for the depth dimension, the "essence of experience, beneath and beyond the surface," extracting meanings the artist may never have intended. *But there is nothing intrinsic within a work of art that forbids us to experience it in the spiritual dimension—or that forbids any interpretation, for that matter.*

Marcel Duchamp, one of the most influential artists of the twentieth century, wrote that "the creative act is not performed by the artist alone; the spectator brings the work in contact with the external world by deciphering and interpreting its inner qualifications and thus adds his contribution to the creative act."[9] The viewer is an essential element of the artwork.

Art As Communication

Giving such weight to the viewer's part in the experience of art supposes that art is more than just self-expression, or else artists would be the only beneficiaries of the creative act and the works they produce might just as well be closeted or destroyed. If art is expression, and many people seem to think it is, it is an expression perceived by another and calling for a response. In this sense it has parallels to other forms of communication. (More on art's purposes will follow in chapter 3.)

In any act of communication, the sender—in this case the artist—does not act alone; indeed, the success of the transaction rests not only with its transmission through a medium such as paint or marble or film but ultimately with the receiver. No communication is complete until it is received.

The Responsibility of the Receiver

Viewers bear considerable responsibility for the artwork's interpretation. Those who expect to sit passively by while the art does something to them are missing the point. It cannot be stated too strongly or too often that *the viewer is a full partner in the transaction.* The artist who finishes a work and displays it for others to see relinquishes further control over it. If perception is necessary to visual communication, then the viewer's response is a necessary part of the artwork's completeness.

Not all artists are comfortable with this notion. Georgia O'Keeffe, the beloved twentieth-century painter of stark southwestern landscapes and of flowers that draw us into an almost-embarrassing intimacy with nature, complained about the "strange things people have done with my work."[10] But whatever she may have felt and intended when she made a particular painting, as you stand in front of it there is only the painting and you. Whatever you may have learned about the artist, the image before your eyes merges with your own history, and for those moments the painting is yours alone.

Commenting on the viewer's role in the communication of art's spiritual content, the painter Mark Rothko wrote that the instant a picture is completed, the artist becomes an outsider who must experience the work, like any other viewer, as "a revelation, an unexpected and unprecedented resolution of an eternally familiar need." And, "If I must place my trust somewhere, I would invest it in the psyche of sensitive observers who are free of the conventions of understanding. I would have no apprehension about the use they would make of these pictures for the needs of their own spirits. For if there is both need and spirit there is bound to be a real transaction."[11]

For the viewer, participating in this transaction offers a lifetime of rewards. In a letter to her son, a mother wrote: "To me art is one of the great resources of my life. I feel that it enriches the spiritual life and makes me more sane and sympathetic, more observant and understanding. . . ."[12] The mother was Abby Aldrich Rockefeller,

one of the three initial founders of the Museum of Modern Art in New York. Her active, ongoing spiritual encounter with art in turn brought rewards to millions of people through the museum's exhibits, programs, and support of the artists of our time.

Of course one not need be a wealthy patron of the arts to enjoy art's spiritual bounty. Scores of university art appreciation students, most of them non-art majors fulfilling a humanities requirement for graduation, have written or told me that being forced to spend time observing and actively engaging with certain artworks has revolutionized their experience of art (especially contemporary art, which they previously had dismissed or viewed as a joke), and has enriched their inner life.

The Artist's Role

Granting the viewer's importance, the obvious bears stating: embodiment of Spirit in art begins with the artist. It may be helpful for viewers to reflect on the effort and experience that go into the making of visual art.

Most artists begin with a spark of inspiration, a love of making images, an urge to create. But inspiration alone does not make artists. There are years of learning craft, studying other art, exploring ideas, investigating techniques, innovating. Practicing. Coming upon dead ends, retracing their steps, trying again. Failing. Working even when they feel empty and dry. Performing the hard or tedious physical labor of art—building, mixing, bending, lifting, pouring, throwing, finishing. Carrying portfolios to art galleries and dealers. Facing rejection. Carrying on.

In spite of all that, artists often speak of a *holy act*, of the spiritual dimensions of their creative work. Henri Matisse said more than once that he did not believe in God . . . except when he was working.

Paul Kleé wrote: "My hand is entirely the implement of a distant sphere. It is not my head that functions but something else, something higher, something more remote."[13]

Pablo Picasso: "Painting isn't an aesthetic operation; it's a form of magic designed as a mediator between the strange, hostile world and us, a way of seizing the power by giving form to our terrors as well as our desires."[14]

Not all artists describe their creative act in such transcendent terms, but through the centuries most have acknowledged that they are not entirely in control of the process—whether they credited the muse, their subconscious, or God.

Art and Spiritual Healing

Being out of control is not the exclusive property of artists. It has been suggested that the attempt to gain an illusion of command over one's existence underlies the will to create images. Some may seek it through knowledge—ironically magnifying their lack of control, for what we can know is a microportion of what we feel, and what we can articulate a mere outline of what we know. But we can sense the unknowable as well as the seemingly inexpressible—in one artist's words, the holiness of the universe—through images, the visible Word. In the materials and the structure of art, humans can see and be grasped by the inner working of the Spirit, sense it through space and movement, hear in its silence the soul's song. In his essay "Beyond Belief: On the Spiritual in Art," the critic John Perreault writes that such art even transcends time and place.

> My intuition tells me that art certainly must attempt to be more than merchandise and that it probably must be more than self-expression. . . . Art can go beyond merely reflecting the times we live in. It can assist in meditation and contemplation—there is a long tradition of this—and it can enlarge consciousness. Art can also heal.[15]

Images can impart unsparingly the depths of our existence, of truth, suffering, hope, and joy, regardless of whether the

image maker verbally acknowledges that intent. Herein lies their healing power. We artists do not have the last word on the meaning of our art. The art itself—as beheld by the viewer—is the last, silent, resounding word.

Silence resounds in a small chapel on the campus of the University of St. Thomas in Houston, known as the Rothko Chapel for the artist who created it. It is a spare environment. The paintings that cover its walls are mostly black, with subtle variations of color and brushstroke that require time and a quiet and contemplative attitude to perceive.

This is not a sanctuary for ritual and celebration. Nor is it a complex or unsettling moral declaration. It is a place for quiet meditation, for cleansing, for an emptying of one's self. The black walls become a barrier against the trivial noise and clutter with which people fill their emptiness. They might symbolize the death of appetite and of the desire to possess one's own life. The artist is the same whose words opened this chapter, reflecting that art is "an anecdote of the spirit . . . making concrete the purpose of its varied quickness and stillness."

What Rothko's creation can be for one who waits in its stillness for the Spirit's voice, in the end it was not to be for the artist himself. His patron for the chapel wrote: "As he worked on the Chapel, his colors became darker and darker, as if he were bringing us on the threshold of transcendence; the mystery of the cosmos, the tragic silence of our perishable condition, The Silence of God."[16] These paintings were to be among his last; shortly after their completion, Mark Rothko died by his own hand.

The visible Word grasps the senses and the inner life with a passion and efficacy that words can seldom command; and yet without an intelligible faith art's potential for spiritual insight and healing may elude not only the viewer, but the artist as well. Michael Tracy assailed institutional religion—but not against faith. Mark Rothko succumbed, in his final act, to despair. Still their works give us, in one an occasion to confront the abyss, to

deal with our darkest side; and in the other a purifying and heal-
ing presence as we surrender to the silence and wait quietly for
the Word to address us.

Two

Forming Spirit:
Art As Practical Theology

> God created the arts in order that life might be held
> together by them, so that we should not separate our-
> selves from spiritual things.
> —St. John of the Cross

Theology has been defined in various words as a reflective response to God's activity in the world. For a very long time, and in apparent contradiction to that definition, academic theologians have tended to value the theoretical over the practical, and words over images and deeds. Many people still view practical theology as an addition to "real" theology, a sort of adjunct to the theoretical.

But practical theology is not only for the clergy, and it is more than helping folks, operating fax machines, or writing sermon outlines. Practical theology is not even the practical *side* of "real" (meaning linear, language-based) theology; it *is* real theology. We meet God first with our senses, in the specifics of daily, material existence.

This is not meant as pantheism. Simply living as a sensory being is no guarantee of meeting God. Practical theology is

practical, and it is also theology. It is an embodiment and a reenactment of the mystery, and of the event of God's intervention into human life. It is reflection on and response to that event.

Surely art is a part of that response. Rather than explain meanings for us, it helps us to form meaning, embodies meaning, is itself an act of meaning. In that respect, it can be seen as practical theology.

The present chapter will examine the embodiment of spirit in matter and the tension between the material and the transcendent that characterizes human life. There is danger in tending half of one's nature, whether physical or spiritual, to the neglect of the other half. Meaningful symbols are needed that involve us as integral physical and spiritual beings, and that enable us to reenact meaning in our own lives. Art can serve as one of these symbols.

Embodiment

The transcendent realm reveals itself in union with material things. That is embodiment. It brings to my mind an image from childhood: our grandmother's patchwork quilt that lay across my bed. Often I would flop across it, daydreaming. I picked out familiar patterns and remembered the people who had worn them, traced rows of tiny even stitches where Grandma's freckled hands had worked a needle through layers of stretched cloth and woolen batting.

What in this work of art and love held such fascination for a girl of eleven? Surely not its function, though a warm cover is a thing of great value on a cold Minnesota night. Probably not my grandmother's talents as a designer, though it was richly decorative. I was drawn to the material itself, arranged and pieced together with care. Scraps of an aunt's Easter dress. Pieces of Grandpa's cotton flannel robe, my own father's plaid pajamas. A faded silk tie, I wonder whose? A corner of the old kitchen curtains, truncated cabbage roses cut from the basement daybed

cover. Remnants of flour sacks out of which that humble artist had scooped her family's bread.

I knew that this fraying coverlet was not in actuality the people who came before me—some older now, others dead. It was not, literally, a loaf of homemade bread, a musty basement full of treasures, a humid and fragrant kitchen. But for me it became all those things. It made them alive, embodied them so that I relived them. No well-turned phrases, nor the most finely designed and crafted *tour de force* of purchased, color-coordinated calico, could grasp my imagination like that particular patchwork quilt, symbol of one family's life together, born of thrift and industry.

Just as the quilt made a part of my past happen for me and gave it form, so can painting, sculpture, music, dance, poetry embody some truth or another, some depth, some real thing that escapes our prosaic intelligence and language. The materials of these quilts of human art may be bits of paint or steel or plaster, but they also are a rush of wings and feet of clay, inaudible cries and indecipherable longings; memories of people we have never known and souvenirs of places we have never been. They are suffering, panic, hope, space, wonder, restraint, hunger, disappointment, satisfaction, purity, texture, mystery, God.

Art has the potential to hold matter and spirit in tension, and thereby to mirror human existence.

Body and Soul

Many years ago I sat in a high school Shakespeare class listening to Mr. Frisius (a big, unkempt, passionate man who captivated us by sharing his struggles to grasp the mysteries of life) announce what he thought to be the great paradox: "I can conceive of God . . . and yet I have to go to the bathroom!"

In our actual existence there is no soul-versus-body split. It is true that at various times in history the physical world, and visual art in particular, has been viewed with distrust or fear. (See the discussion of iconoclasm later in this chapter.) But having to go to

the toilet is as much a part of being human as is thinking about God.

"By nature we are a part of nature. By nature we are apart from nature."[1] John Dixon's words sum up what Mr. Frisius sensed; it may well be a central paradox of human life. We live each moment in a tension between the material reality of our bodies and our physical universe, and simultaneous awareness of some other reality, intangible but *there*, beneath and beyond our inescapable physicality.

Part of Nature

My grandmother's quilt was a physical thing that I could touch and smell and see. Such is the substance of my life. I am a body—a material being inhabiting a material world. My life is made up of lines, points, textures, color, shapes, dark and light, mass, weight, planes, volumes, sounds, smells, coolness and warmth.

I am subject to the limits of *time*. (Human awareness of time's restraint may explain the prevalence of human fantasies about getting out of time—reincarnation, time-tripping. My thoughts and feelings may move freely about, but my body is trapped in chronology: this moment must follow the last, and I must live it before I can go on to the next. Time gives structure to my days.

Space also limits me. I occupy space, move through it. I cannot (to use a *Star Trek* analogy) beam myself up or down or over to any place I wish to be. In order to go from our house in Texas to our summer cabin in northern Minnesota, Howard and I must spend a certain amount of time physically moving our bodies 1,225 miles north, slicing through the geographic center of the country. There is no escaping it; space gives structure to my movements. Time and space are inseparably tied, and outside their dimensions I have no way to shape my existence (see chapter 6).

My *senses* provide for every thought and desire and feeling. Life revolves around such things as I can see and hear and taste

and touch and smell. I experience the love of another through the sight of his grin, the sound of his voice or his breathing, the particular scent of the hollow of his neck. A sudden loud noise sends a rush of adrenaline through my body. I place a bite of left-over food in my mouth, and its rancid taste tells me to spit it out. The telephone rings, I hear my daughter's *Hey!* from four thousand miles away, and her generous spirit buoys me. These physical senses determine my actions, feelings, thoughts, my very consciousness.

Not only am I limited by time and space and guided through the material world by my senses; *I, myself, am matter.* The physical, sensory details of material existence shape my days from the first groggy moment of awakening. I am flesh and blood and water, bone and hair, sinew and bile. So are you. So are we all.

We are animals. Our hearts squeeze blood through our veins. We sneeze, cough, digest our food, sweat, feel a chill. Our muscles ache after uncommon exertion. We lose our balance. Bump into things. We have a territory, a real physical one, which we stake out and patrol like the rest of the animals. At night we nest, as birds and dogs nest, drawing our bedding around us.

We feel exhilarated after a brisk walk or a game of tennis, sluggish after a holiday feast. The chemistry and physiology of our brains affect the way we think and behave. Drugs can alter our emotions only because they alter the material of our bodies. A sprain, a toothache, a touch of the flu sullies our outlook on life, and renewed health fills us with good humor.

Apart from Nature

Even though we are animals and thus part of nature, humans also are separate from nature. As we move within this sphere of the material, we cannot escape the nagging and age-old awareness that there is something else, some Other, that is beyond or beneath or separate from objective reality. We cannot name it, but we try. Augustine called it a certain restlessness; Tillich, the depth

dimension. This something else, this depth, this restlessness, also has been called (to list a few) the other, transcendence, being, ultimate meaning, the ontological, higher power, Spirit, the mystery. I will not attempt to choose one term in exclusion of the others, for each in its imprecise way approaches a slightly different sense of the depth that we seek. Each acknowledges the spiritual dimension of human life.

As Mr. Frisius told his class some forty years ago, we *do* conceive of God.

The mystery is not a riddle to be solved. It is permanently enigmatic. Uncovering more data will not bring us closer to solving or understanding it—though it may bring us closer to an opportunity for some communion, some participation in it. We sense the mystery, and we are drawn to it.

Out of Whack

Flesh and blood. Mystery.

It takes grace and perhaps a certain gift to live poised between the many tensions of our existence, not least of which is this tension between matter and spirit. It is important to remember that we are both. There is a real danger of emphasizing one to the neglect of the other, thus living a life that is unbalanced, incomplete, out of whack.

Looking around us it is not difficult to see how easily humans neglect their spiritual natures in favor of the material. The ontical, earth-bound stuff of day-to-day life does not encourage us to experience the ontological; we shrug off issues of meaning and find little time to contemplate the nature and source of existence. Though we are drawn to this depth, often we fear its terrors and its truth.

Living physically in a material space is part of our reality, part of what makes us human; yet some people grasp onto the materiality of their surroundings with a pathetic desperation. They objectify emotion, belief, beauty, other people, self, God—

turn them into commodities to be owned or traded upon, quantities to be measured, manipulated or controlled. They avoid acknowledging the other for which there is no adequate name.

The Abyss

Even amidst the abundant opportunities of modern life, we remain at the edge of a void between what is and what might be. To the extent that we try to fill this void with ontical things, that is, objects or their equivalent—money clothes beauty success power learning food drink fitness work sex comfort drugs status—the abyss only yawns wider. The more we feed it, the more it wants. In his short story "A Clean Well-Lighted Place" Hemingway acknowledges that nothingness: "What did he fear? It was not fear or dread. It was a nothing that he knew too well. . . . Some lived in it and never felt it but he knew it all was *nada y pues nada y nada y pues nada.*"[2]

False Gods

Perhaps by telling themselves they are satisfied with their impoverished symbols—with success, with comfort and possessions, and with their lives as they are—many people may live out their lives on the surface. What ontological sensitivity they once possessed is drowned in the sound and fury of things; they worship the creature rather than the Creator (Romans 1:25).

Others, sensing the mystery, may interpret its permanent enigma as hopelessly unapproachable, and so live out their lives dissatisfied.

Reducing Spirit

Possessions or position or temporal pleasures are not the only idols that threaten spiritual equilibrium. In the platonic hierarchy that continues to influence our view of things, the intellect occupies an upper level; it deals with abstractions, with ideas rather than objects. But it is possible to objectify even ideas and beliefs. The mystery is named and labeled and measured. The

words formed about it become the last word on the mystery, theological jargon, bumper sticker slogans.

But systems of knowledge are by nature reductive. The more we know or analyze or figure out, in the intellectual sense, the more we reduce—and, potentially, the more inaccessible Mystery may become.

Limited by Words

Words do not, in and of themselves, open us to mystery or bring us closer to being. They are virtual, intangible, ephemeral. In fact, words-about can become a kind of idolatry, denying experience.

All of our theological words are valuable; they can open up a process for us, but like all words they remain abstractions (see chapter 1). They are not something in themselves; they are "about" something.

On the other hand, we cannot discard words and become wholly spiritual—not even through a lifetime of the contemplation of beauty, of prayer and meditation, of self-denial, or any other avenue toward spirituality that people have traveled through the ages. We remain physical, material beings who not only have to go to the bathroom but who live among others, and words guide us as we move and interact.

Denying the Flesh

Living without regard to the physical side of existence can result in imbalance as well. There is the matter of ill health, or in rare extremes death, resulting from self-denial. Isolation is another product of otherworldliness—a loss of possibility for communion with great numbers of people who reside squarely in the material world. But even more, by denying the flesh we may deprive our very souls of the visible Word, embodied in nature and art and perceivable only through physical means.

To deny the flesh, in a sense, is to deny the Spirit.

Image-Smashing

One example of "spirit only" imbalance germane to the present discussion is on-again, off-again iconoclasm in the history of organized religion. Since ancient times when the Hebrews were forbidden to make graven images—perhaps as a way to preserve their unique identity amid surrounding city-states that worshipped idols—the Hebrew-Christian tradition has vacillated in the matter of religious images. (Islam has been more consistent in forbidding visual representations.) The ferocious iconoclasm of the ninth century, occasionally repeated cyclically in ensuing centuries, may have been rooted in acknowledgment and fear of the image's power (see chapter 1). A great many iconoclasts were not content simply to discourage or forbid or cover up images; they hit them with sledgehammers, burned them, hacked them to bits. (In fact, the word *iconoclast* means, literally, *image smasher*.)

Perhaps ancient and modern iconoclasts have acted out of the old platonic suspicion of the material world, with its notion of a hierarchy of creation—inert matter occupying the lowest levels and spiritual things at the other extreme—that swayed Christian thinkers such as Augustine. (Francis of Assisi had a different view. His worshipful *yes* to nature influenced the Renaissance affirmation of physical reality as worthy of study and delight.)

A few of the Reformers who forbade images in churches remained open-minded about art in other settings, but feared idolatry in the picturing of anything related to the story of faith. (Reformers were divided on the issue of images; some of them destroyed and banished images, while others saw them as beneficial and even essential.)

It is also possible that this age-old clash between art and religion occurred and still goes on because the two have so many parallel functions that visual art is seen as a threat to religion.[3]

The reasons are less important than the result. Many churches embrace a one-sided spirituality that inadvertently becomes an idolatry of words, a different kind of objectification. They discount the visible word and hide from our eyes the

embodiment of Word in paint, plaster, glass, textiles, stone, and steel—that is, in art.

Art As Reenactment

Certain forms of human experience embody the mystery, disclose its depths even while allowing it to remain a mystery. All of these experiences involve us as not only spiritual but also physical and sensory beings. To achieve balance in the tension between matter and spirit we need a thoughtful participation in something palpable and perceivable—a kind of *reenactment* that integrates image and word.[4]

There is more to being human than language can explain. There is something hidden and yet revealed, transcending the world not only of objects but also of facts and even ideas, belonging instead to the territory of image and symbol.

Starved for Symbols

Sometimes it seems that the life has been squeezed out of all the old symbols, and that our new ones are inadequate. Here I am speaking of symbols in Tillich's sense of the word, as images that participate in a reality rather than merely point to it. For example, an inverted triangle signals motorists to yield right of way only if they have been taught so, whereas water symbolizes cleansing because water cleanses, and light symbolizes knowledge and understanding because light reveals. Many images have multiple layers of symbolic meaning; fire, for example, may convey warmth, purification, danger, destruction, inspiration, or passion.

People are being slowly starved for symbols that can help form meaning in our technological age. The burgeoning of new-age spirituality, sects, and glitzy television religion seems to suggest a yearning for images to ground and guide us in a complex and fast-changing world.

Proliferating Images

Thanks to electronic media, to print and transportation and photography and computers, we are enriched by an unprecedented array of useful, thought provoking, sometimes inspiring and, yes, often banal images. We also are becoming expert at screening them out, for we cannot hope to process the quantity of sights presented to our eyes daily. This is a concomitant danger of a culture teeming with sights.

Impoverished Images

Paradoxically, or perhaps resultantly, the images and symbols of modern life are bankrupt. Many of them are only about technique and surface appearances. (Which will we screen out? The billboard cigarette advertisement? Liturgy? Scenes of violence on the evening news? The art we pass in public places? Television commercials? The faces of those who serve us?) Even the word *image* has come to mean *facade*: one's public image may bear little resemblance to one's inner reality.

Early in the twentieth century, Carl Jung recognized the growing hunger for meaningful symbols. He believed, as Ira Progoff explained, that "It is the deadening of images which once had a vital power that lies at the source of the confusions in modern consciousness"; having "only a morgue of symbols to supply them with the meaning of life . . . confusion, paralysis of spirit, and ultimate breakdown are bound to result."[5] People still desperately need symbols to supply them with meaning—whether they be new symbols, or new meanings for old symbols, or both.

Art As Symbol

To this inadequacy of symbols, art replies. Certainly it is not the answer; art is neither substitute for nor variant of religion. It does not necessarily convey ultimate meaning.

Some art simply combats joylessness: it is sensual delight.

Some art is self-indulgent.

IMAGE
AND
SPIRIT
ILLUSTRATIONS

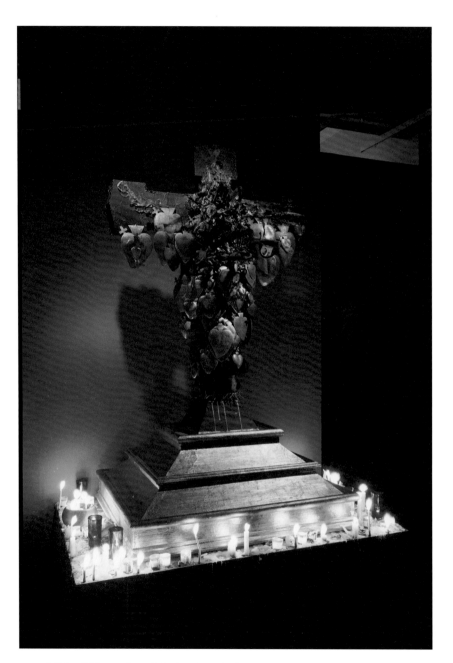

Michael Tracy. *Cruz de la Paz Sagrada (Cross of the Sacred Peace),* 1980, installation view from Chapel, 1981. Wood, rayon cloth, acrylic, hair, nine swords, crown of thorns (cactus, string), tin and bronze milagros, and oil paint, 72 in. x 48 in. x 36 in. The Menil Collection, Houston.

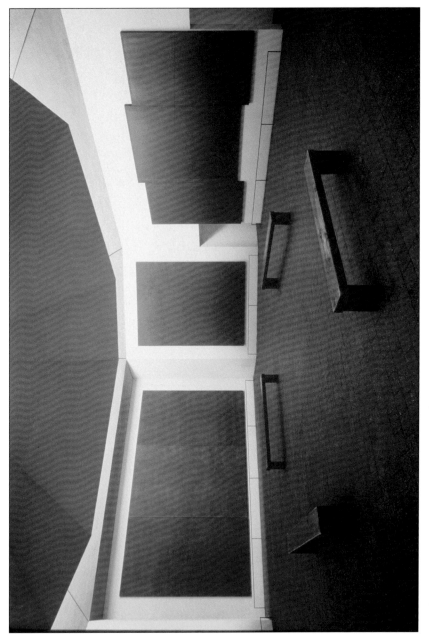

Mark Rothko, *The Rothko Chapel*, interior, 1971

Clyde Connell. *Song from Bistineau*, 1979. Brown paper, rice paper, mulberry paper, graphite, charcoal, 101 in. x 66 in. Collection of Bryan Connell.

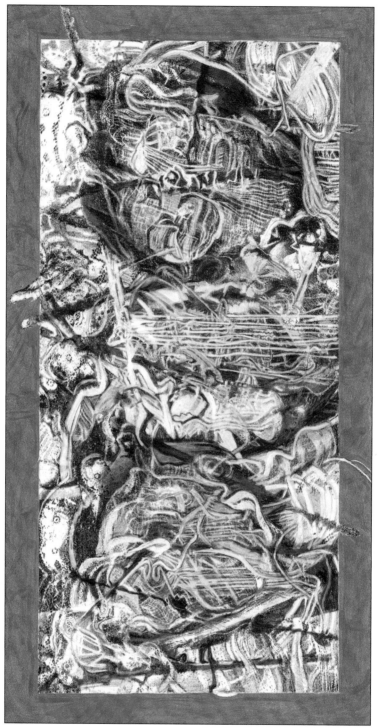

Karen Stone. *B.P. (After Jackson Pollock)*, 2001. Mixed media on paper, 10 in. x 17 in.

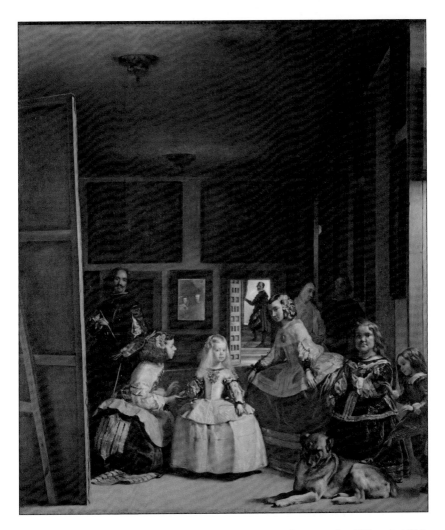

Diego Rodriguez de Silva y Velazquez. *Las Meninas (The Maids of Honor)*, 1656.
Museo del Prado, Madrid.

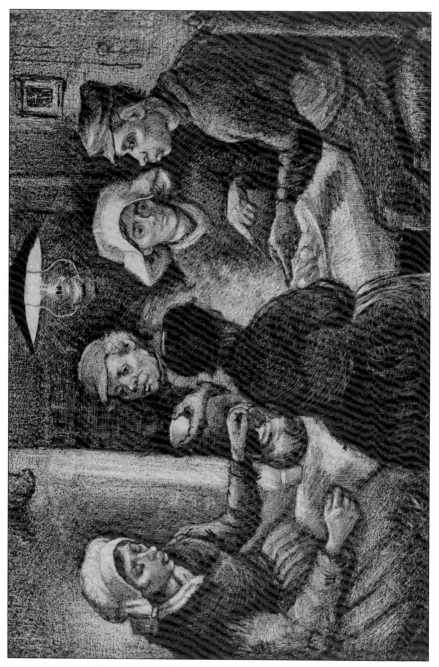

Vincent van Gogh. *Potato Eaters*, 1885. Lithograph, 21.5 cm x 31.4 cm. The Museum of Modern Art, New York.

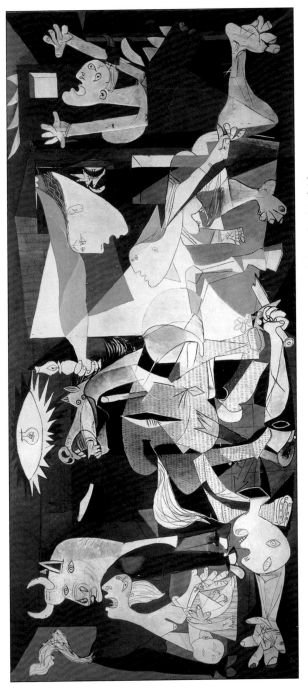

Pablo Picasso. *Guernica*, 1937. Mural, approx. 11 feet 6 in. x 25 feet 8 in. Museo del Prado, Madrid.

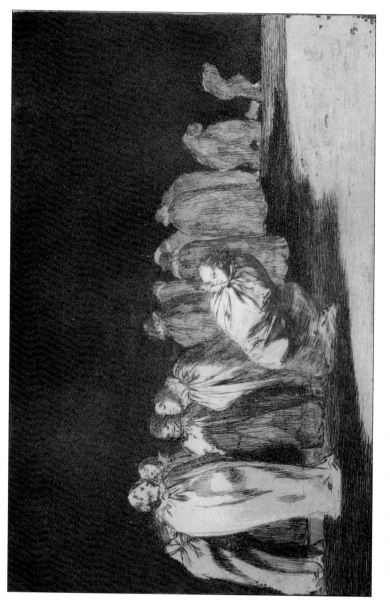

Francisco Jose de Goya y Lucientes. *Los Ensaches (The Men in Sacks)*, from Los Proverbios series, published posthumously in 1864. Etching, 248 mm. X 359 mm.

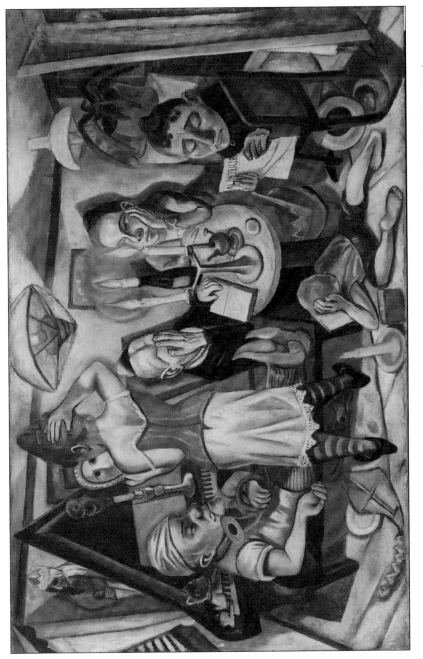

Max Beckmann. *Family Picture*, 1920. Oil on canvas, 65.1 cm x 100.9 cm. The Museum of Modern Art, New York.

Karen Stone. *Chalice,* 1998. Black and white photograph, 8 in. x 10 in.

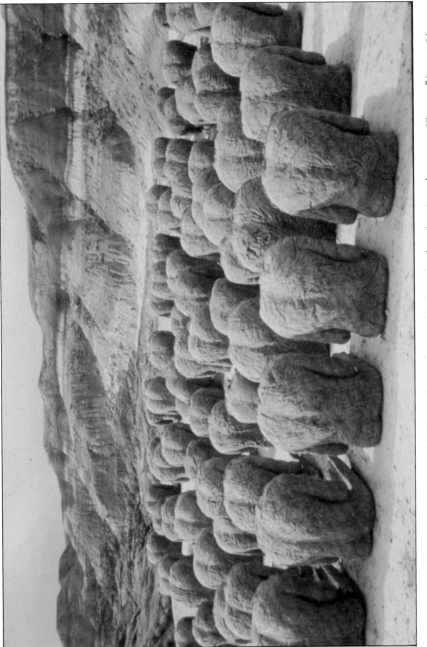

Magdalena Abakanowicz. *Backs*, 1976-1982. Burlap and resin, 80 pieces (each unique), each approx. 69 cm x 56 cm x 66 cm.

Anselm Kiefer. *Quaternity*, 1973. Oil and charcoal on burlap, 118 1/8 in. x 171 1/4 in. Collection of the Modern Art Museum of Fort Worth.

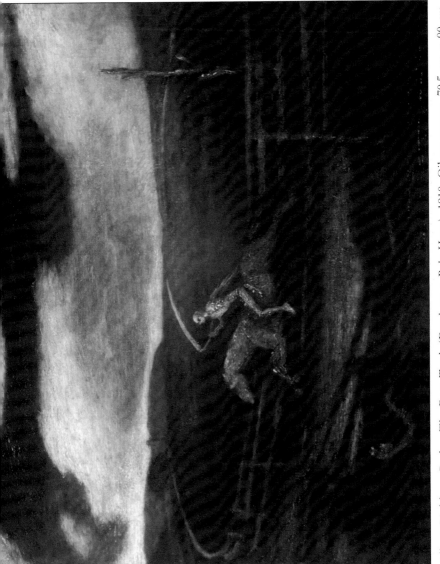

Albert Pinkham Ryder. *The Race Track (Death on a Pale Horse)*, 1910. Oil on canvas, 70.5 cm x 90 cm. Copyright © The Cleveland Museum of Art.

The simplest tool for analyzing color relationships is a color wheel. Start with the primary colors, which cannot be obtained by mixing other colors: arrange spots of red, yellow, and blue in a widely spaced triangle. Add secondary colors to form a circle in the following order: yellow, orange, red, violet, blue, green, and back to yellow. Insert tertiary colors such as yellow-orange and red-violet in their logical spaces.

Some art is literal: academic, didactic, propagandistic, a substitute for words.

Some art is trivial: bric-a-brac and little more.

Art is.

Art is not only expression or communication. It can be more than decoration. It has form and content, yet it lies outside form and content in that it simply is. Something is formed in its making—an act, not a message. That something occurs between the artist and the work, but it also occurs in the viewer's active engagement with the work: art forming Spirit.

Art embodies.

Art is unique in that it unifies the material with the spiritual. There is no way to perceive the spiritual without the material; conversely, without spirit the form yields no lasting truth. Art's form is material, yet it deals with inner reality. It is embodiment. In art, we encounter and re-form images by our own participation with them.

Art reenacts.

We cannot measure out the mystery, or solve or decode it, but we can enter into it, take part in it. Art is one such reenactment. Through acts, such as touching charcoal to a sheet of rag paper, lying prone on a patchwork quilt, or standing silent before a painting, we reenact—or act out or embody—the indefinable meaning of our lives. And reenactment, unlike reduction, is a process that enlarges and expands our awareness.

Art provides the experience of reenactment because, no matter what the artist intended, experienced, or claimed for that artwork, to the viewer-participant it is a singular event and the viewer's own background, thoughts, and intentions have their claim upon it. The creative act, to repeat Duchamp's words, "is not performed by the artist alone; the spectator brings the work in contact with the external world by deciphering and interpreting its inner qualifications and thus adds his contributions to the creative act."[6]

Reenactment, as one contemplates a work of art, does not duplicate the original event that created it. Art continually allows

a new reading, becomes a new image. Specific verbal conceptions of God may outgrow their usefulness, change, need revision; but visual images are different. Though they are concrete, they go beyond specific meanings. The people, the places, the times, the languages, and the spiritual needs may change, but art can be infused with new meaning and can convey enduring truth.

If indeed the transcendent realm reveals itself in union with material things, then art can be a fundamental forming activity of our lives. It is a union of mystery and illumination like my grandmother's quilt, which gave me no knowledge or facts about my family, yet made them real to me.

Art allows us to participate in the mystery. It reveals at the same time that it hides. As it unfolds, the mystery deepens.

Three

Art's Intent

The object of art is not to reflect the visible but to make visible.
—Paul Klee[1]

In a wide, low-ceilinged cavern two hundred meters deep in the earth, human figures move about. Their only light is supplied by burning wicks immersed in shallow bowls of melted tallow. Into pigments extracted from soot, minerals, or berries and mixed with animal fat, they dip brushes made of chewed reeds and paint images of animals onto the cave walls. There are deer, bison, cattle, antelope, horses. Sometimes a contour of the wall—a hump or a depression—suggests a particular animal and so they outline the shape and supply the appropriate details. More often they pay no regard to what is already there, superimposing their painted creatures on top of other, more ancient images.

Fifteen thousand years later the pictures are still there, remarkable in their accuracy of representation.

For some thirty millennia, humans have been making images. There are no times and few, if any, civilizations that have not produced them—not, at least, in the broad definition of image offered in chapter 1. Groups that forbid the making of

pictures or representations of living things substitute poetic images, such as the psalms, and abstract pattern. In Islamic cultures, for example, handwriting is not the functional, unconsidered scribbling we make of it but almost an art form in itself, verging on representation.

In her two-dimensional works, Clyde Connell carried such calligraphy to an intensely spiritual level. She covered huge, laminated sheets of brown paper with mysterious signs reminiscent not only of Islamic manuscripts but of Egyptian hieroglyphs, markings in the catacombs, the secret codes of inmates scratched on prison walls, and above all, of music. Connell's rhythmic, spontaneous "writing" summons forth remembered sounds of forest and swamp, as well as the haunting sounds she heard from prisoners at night during the years when her husband was superintendent of a Louisiana penal farm.

Image making is universal in human history; the present chapter will look at reasons why. It will offer a working definition of art (no final definition is possible) and examine various purposes for art through the ages—dividing them into categories that will be useful for viewers seeking the ability to understand art's deeper meanings.

Defining Art

Can you define art?

Pause.

Yes. No. Maybe.

Is it important to define art? After all, many of our experiences elude definition—love, for example, or any of our complex emotions. Is not art one of those indefinable things?

It is difficult to talk about things we have not defined. When I say, "I love you" to a friend, there is a tacit definition of the word *love* in that context. We understand that it does not include sexual attraction (otherwise some embarrassing misunderstandings may result). We also agree that it means more than "I admire

you" or "I like the way you dress," and that in a declaration of love I make myself vulnerable.

Like love, art seems to have resisted consistent definition for a long time. Perhaps, though, art does not so much resist definition as attract it; it seems there are as many definitions of art extant as there are people offering them. We define anything for a reason, and as the reasons change our definitions change. Each new discussion requires a new definition.

To Define Is to Limit

Definitions put boundaries around things. Some people would oppose placing any limits on art; Andy Warhol, for example, once said art is anything you can get away with. Forty years or so earlier, Kurt Schwitters claimed that anything an artist *spits* is art. Both Warhol and Schwitters had good reasons for explaining the nature of art in such ways, and for their needs those were valid definitions. Both were striking out at old notions of what art could and could not be. But their definitions fail to define: anything and everything is art, and consequently nothing is art. (Perhaps this was their point.)

What Counts As Art

In our time many art professionals—museum curators, critics, and the like—accept whatever an artist makes and identifies as art to be so, which also seems indefinitive until you notice that it requires an element of *intentionality*. For spittle to be art, it must be part of a deliberate creative act.

But, as Frank Burch Brown pointed out, this practical understanding of art—in short, "what counts as art"—approaches the vacuousness of the facetious Greek definition of a human being as a "featherless biped."[2] It ignores (though perhaps does not rule out) works of skill and insight by people who did not or do not consider themselves to be artists—whether out of humility or ignorance or simply because they do not separate image making from other essential acts of their lives. And it

evades aspects of the making and of the product that are hard to ignore when we begin talking about actual artworks and not just art in theory.

To Define Is to Separate

To define is not only to limit, but also to distinguish or separate a thing from any other thing. It may be better in this regard to define a *work of art* rather than *art* as a concept. What makes an artwork distinct from any other product or act of human making?[3]

Intention

As the art professionals' definition implies, whether it is an event or an object, art is the result of a conscious and deliberate act. The sculptor Jene Highsten, asked what is the difference between his huge, rock-like, monolithic sculptures and natural boulders, replied that boulders "are the result of a natural force. They have no intent."[4]

A sunset is not a work of art.

Knowledge and Skill

A work of art also is the result of some knowledge or expertise on the part of the artist. This does not mean that technique or eye-hand coordination makes an artist. A number of contemporary artworks puzzle viewers because they seem to involve no craft, no apparent skill; but they are the results of what Burch Brown calls an "informed act," a union of ideas and materials.[5]

A painting by a monkey is not a work of art.

Aesthetic Purpose

Third, a work of art has some aesthetic intent or effect. This is not to say that the image is necessarily attractive to the eye of every viewer. Remember that *aesthetic* refers to heightened sensory awareness. It is the opposite of *anesthetic*—that is, a dulling or loss of consciousness—not the opposite of *ugly*. Aesthetic standards are culturally learned and entrenched. Definitions of beauty, for

example, may be harder to arrive at than definitions of art, and beauty of form may be found in images that most people would overlook or find unsightly: a flattened glove lying by the side of the road, a peeling and weather-worn storefront, the lined face of a very old man, crumpled grocery sacks, billboards, garbage, a dead bird. None of these is art, but all have been subjects for artists who explored their aesthetic potential. Even primitive, functional artworks such as Paleolithic cave paintings of horses and bison, though perhaps made with no conscious aesthetic intent, have a marked aesthetic *effect.*

A sketch of an electrical circuit is not a work of art.

Interpretation of Reality

Finally, much art goes beyond or beneath the surface of things; it *interprets* reality. It may be argued that this distinction is a matter of quality rather than definition, for at the very least it would omit a great many works to be found in shopping mall art exhibits, arts and crafts fairs, and the like. To include this fourth criterion requires confidence in one's ability to judge, and an openness that few could claim to possess. It calls for discernment between art-works that have integrity, originality, and a certain presence, and those that are empty, trite, or commercial. (See the discussion of judgment in chapter 7.) Yet it is the visionary and the spiritual that many people find worthwhile in art. We look for (yearn for, need) images that bring us beyond literal reality, that challenge our assumptions, that offer us a new truth. Perhaps it is this need that lies beneath the eternal impulse to create.

We may allow that the formulaic image of a certain mass-market painter is art, but it offers little insight, and virtually no fulfillment of our ontological longings.

Purposes of Art

Attempts at defining art, in order to be inclusive, cannot address art's goals. The important thing about the purpose of art is that it

is never simple, it is changeable, no two artworks ever have exactly the same purpose, and seldom if ever does one work have only one purpose.

One reason it is tempting to believe there is a sole and central purpose for art is the consistency with which humans have engaged in image-making. At no time have people done without making images, or art, in some form; it would seem that art is a central feature of human existence in some basic way.

But just as probably it is art's *forming character,* and not any one purpose, that makes it a universal activity. Art answers any number of problems, fulfills a multitude of needs, meets an infinity of intended purposes, because images are at once tangible and immaterial and because human beings likewise are equally of nature and apart from it.

Much of what was written in chapter 1 might suggest that art's essence is to convey meaning—in Rothko's view to make concrete the movements of the Spirit. Some art has a message or moral—sermons in paint, as it were. Some art is intensely personal, expressive of the loneliness or fear or hope or despair of one human being or us all. Some art is an act of magic. Some art imitates reality or documents things no longer present.

Art has expressed ideas or pure sensuality. It has incited riots and revolutions. It has made money for a very few. It has dispelled boredom, and caused it. It has entertained, made us laugh, made us cry. Shocked and disgusted us. As soon as we try to label art's purposes, we find them expanding.

To further complicate the task, there may be differences between the artist's and the viewer's purposes. Even the oldest surviving works of art are contemporary in the sense that people continue to experience them. Each viewer brings to the art certain expectations and presuppositions and needs that alter the original objective—vastly or subtly, but alter it nonetheless.

Even though art's purposes resist being reduced and continue to change not only over time but also from viewer to viewer, our personal experience of art is enriched by information.

A certain amount of classification, or reduction, is inescapable if we are to interpret art in any meaningful way.

Actually, before evaluating *any* product it is important to understand its purpose. It makes no sense to condemn a butcher's knife because it will not slice tomatoes properly. Whether or not we enjoy films that depict the brutal realities of war, such as *The Deer Hunter*, we can agree that *Singin' in the Rain* is no standard against which to measure them.

The following categories may help us talk about, and begin understanding the purposes of, a given work of art.

Functional

For the earliest humans, "art" as we know it today did not exist. We may call their objects and images art, but they did not. To label an activity is to set it apart from other activities, differentiate and describe it. At its most elemental level, art-making is no more separate from our being than the beating of our hearts, and to name it is merely to designate, not distinguish it.[6]

Thirty to fifteen thousand years ago there may have been no artists, only people making images right along with their other activities. What those early carved figures and wall paintings meant and specifically how they were used is not clear. What is evident: they were not objects to be owned and admired as commodities of an affluent leisure class. There would have been no art museums or galleries to house art objects, no exhibitions, no opening receptions, frame shops, art schools, art festivals. The earliest art objects—that is, what we now call art objects—were functional. They did something, were natural and essential parts of life.

Perhaps the best-known examples of the functional purpose of art come from ancient Egypt, for three thousand years a stable, seemingly changeless society. Much early Egyptian art that has survived is funerary art. This art was inseparably connected to the belief that life continues after death, that in order to make the journey from this life to the next one's image must be preserved.

Faces were individualized and even today look like real people because their function was to be a stand-in, a sort of life-after-death insurance, should the body decay in spite of elaborate attempts at preservation. However, bodies and the majority of other objects (even servants' faces) were portrayed not as they appear to the eye but in their *most characteristic aspect*—that is, stylized or formalized—perhaps for instant recognition in the afterlife, just as modern advertising artists stylize images for our immediate apprehension.

Functional artworks are meant to *do* something, work some magic, have some real use. Other examples of the functional purpose in art are the masks of some Native American and African peoples that, when worn in a ceremony, are meant not only to represent a spirit, but actually to let the spirit into the wearer's body; ritual objects of all kinds; some architecture; and applied art such as glass and clay vessels or textiles.

Expressive

There is a real sense in which all art could be seen as expressive in purpose (expressive, for example, of a community's values, beliefs, economy, rituals, way of life). Expression may not have been a conscious motivation to create in ancient Egypt, for example, but much of what we understand today about their beliefs is a result of the inevitable expressiveness of their art.

Never is it necessary to know exactly what an artwork is "saying" in order to understand that its purpose is expressive. An artist may disclose ideas, beliefs, emotions, even physical sensations such as eroticism or warmth. In this particular sense, expressive works convey the artist's *interpretation* of the subject or feeling or idea. (Even performance art, where the art lies in an act and no object is made, is the manifestation of some idea or impulse.) Most works of art have expression as part of their purpose, however small or large a part it is.

The Greeks, who were students of the Egyptians in design and technique, made artworks that were intentionally expressive:

in the classical period they embodied and conveyed Greek ideals of discipline, harmony, balance, perfection. Later, in the Hellenistic period, Greek art expressed emotion, pain, age, weakness, and everyday life. Ever since then, in greater or lesser degree, expression has been the principal intent of art.

Obvious examples of the expressive purpose in art are emotionally charged or dramatic works such as the works of Goya, Munch, Kollwitz, Beckmann, de Kooning, Neel, Salle, or Tracy. Even eighteenth century neoclassical painting and sculpture, with its polished and controlled surfaces, idealized realism, rational tone, and classical-political-historical content, expressed the principles of its time. The symbolic and stylized icons of the Byzantine era, done as they were according to rigid formulas, nevertheless were intense expressions of spiritual devotion, of guilt, suffering, grief, and consolation. Even the nonobjective, geometric canvases and sculptures that appeared in the mid-twentieth century may convey, variously, ideas about color or shape; a sense of place or weight or permanence, or in other cases of impermanence; a delicate balance or imbalance in nature; mystery; silence.

Decorative

Another early purpose of art can be found from Neolithic times onward, when people began making images to increase the aesthetic appeal of objects and places. Decoration first appeared as abstract pattern. Animal and plant motifs, simplified by stages until they became virtually unrecognizable, were incorporated into the surface design of functional objects. Here we see the pervasiveness of the functional and expressive purposes, for pattern may also be seen as a way of giving structure to the apparent chaos of nature.

At no time since have humans failed to decorate their possessions, their abodes, and even their bodies with images. The nomadic Goths of the early Middle Ages, with no permanent dwellings to adorn, turned the small objects they carried with

them—combs, purses, weapons, bridles—into detailed and sometimes whimsical animal-like creatures, ornaments of decorative beauty. The monks before the advent of the printing press, who painstakingly copied books by hand, illuminated their manuscripts with intricate patterns and designs as well as pictures. (See the discussion of the Celtic interlace in chapter 6.)

In its decorative intent art does not so much communicate ideas or feelings as combat joylessness. It serves as an antidote to boredom and difficulty, the uncomeliness and bareness of our existence. Decoration might well be seen as a kind of expression; surely this need for visual delight is one of the passions unique to our human makeup. And decoration serves a real function, as noted above: it structures not only its immediate space but our environment, our world, our universe.

In spite of this ancient tradition of decoration, some contemporary artists would take "decorative" as an insult, an epithet for art that is superficial and meaningless: "Mere decoration!" Perhaps Isamu Noguchi would have denied that decoration was the purpose for his 28-foot *Red Cube*. It is, as the title suggests, a huge steel cube with a hole running through it, balanced precariously on one of its corners, painted red (except for the hole), dominating two thousand square feet or so of New York City's financial district. Its hot color and teetering pose are a decorative and even witty relief from the gray rectangular sameness of the city street. *Red Cube* repeats and reinforces the structure of the surrounding city in a fresh and surprising way.

Imitative

Cubists such as Picasso, Braque, and Gris, as well as the Italian futurists and many other artists who were to follow—notably Marcel Duchamp in his famous *Nude Descending a Staircase*, imitated nature, but not from a fixed viewpoint like painters had done since the Renaissance; instead they represented nature as seen by people moving through three-dimensional space. "We

never look at just one thing," John Berger writes. "We are always looking at the relation between things and ourselves. Our vision is continually active, continually moving, continually holding things in a circle around itself, constituting what is present to us as we are."[7]

The energetic brushstrokes of the abstract expressionists of the 1950s and 1960s may imitate the chaos and rhythms of modern life or the energy and structure of the city. Even nonobjective artworks—that is, works that have no outside object as their source—in their geometry may imitate the geometry of the universe; a black canvas such as Mark Rothko's panels for the *Chapel* may imitate darkness or the infinity of space.

Formalistic

The formalistic purpose in art (not to be confused with formalism as a movement in art, though the two overlap) has to do with elements of art itself, its physical qualities. "Formalistic" as used in this specific sense connotes the aim of exploring the properties of form itself—such as color, shape, light, balance, and texture (see chapter 6). Often, in the case of painting, it concerns the flat plane of the canvas. Much formalistic art is nonobjective, or nonrepresentational—that is, has no apparent reference to pre-existing forms. Yet there always have been artists who, though they paint recognizable subject matter, are less interested in the subjects themselves than in their *form*. (The painting popularly known as *Whistler's Mother,* for example, was given the title *Arrangement in Black and Grey No. 1* by Whistler himself.) The Cubists broke down forms into geometric planes and angles, analyzed them, distorted them, truncated, and rearranged them. The exploration of form was a very important part of their purpose.

Other artists, rather than explore form in its variety, have chosen to limit the elements used—like Piet Mondrian, who eventually restricted himself to verticals and horizontals, red, yellow, blue, black, and white—and others who reduced their vocabulary of visual forms to a limited few elements.

Does this formal intent rule out other purposes? Certainly not decoration, as in Noguchi's *Red Cube*, which has a strong formalistic intent yet decorates its dull corner of the world with zest. Nor does a formalistic goal necessarily preclude expression of anything beyond its form; to quote Noguchi, "I say it is the sculptor who orders and animates space, *gives it meaning*. . . ."[8]

The Russian painter Kasimir Malevich, having stripped his paintings' form of all but minimal value contrast (white) and minimal shape (the square), wrote: "I have conquered the lining of the heavenly, have torn it down, and, making a bag, put in colors and tied it with a knot. Sail forth! The white, free chasm, infinity is before us."[9] Clearly, the purposes of art permeate each other.

One could go on listing purposes for art almost endlessly. However, beyond functional, expressive, decorative, imitative, and formalistic, other intents for art can be seen as secondary in importance, or can be made to fit into one of those five categories.

For example: *Narrative art*, suggesting stories or, in its broader sense, experience, is certainly expressive and usually imitative— perhaps even functional as it passes on a people's culture from generation to generation. Film is perhaps *the* narrative art form of our time; but narration is a subtle or overt element in even remotely representational art, for as humans we have an irresistible urge to know the stories of others, to relate them to our own stories.

Likewise *didactic art*, which teaches or impresses upon the viewer some moral or idea through representation, is at once functional and expressive and imitative. Artworks that make an obvious political statement are didactic. Byzantine icons, mosaics and frescoes are didactic works that instruct but also convey deep religious feeling.

Documentary or *commemorative* works may be imitative of nature (like a wedding photograph, a history painting, or a colossal fourth-century head of Constantine) or entirely nonobjective (like the Washington Monument or the Vietnam Memorial)— but in any case they express something about the persons or events they represent.

Art for social change often is also expressive, like Picasso's *Guernica*, which documents a specific incident (the 1937 mass bombing of the defenseless Spanish town of Guernica) yet remains a universal witness against war's brutality.

Constant and Changing

Art and its purposes have been changing continually over the centuries. Every new age discovers new purposes, new forms, new definitions. Art never can be defined in a way that rules out other definitions; no art has only one clear purpose. What an artwork is for the artist, it may not be for the viewer. Its meanings will vary according to the times, the experiences, and the beliefs of its public. It addresses a multitude of needs. What individuals and communities expect of art may shift from one moment to the next, especially in our time of pluralism and accelerated change.

And yet there are some constants. Every era has produced works that function—whether passively, like clay vessels, or actively, like ritual masks or talismans. Even the earliest and most functional of images made by humans have the capacity to impart feelings, ideas, sensations. Humans in every time have decorated their lives. All artworks have a form and no artist can escape considerations of form. And even the most enigmatic and puzzling of visual images may be seen as some kind of imitation . . . of the surfaces, textures, and colors of nature if not its identifiable shapes.

Art is always changing, yet its essence, its *juice*, remains the same. As Berger writes, the relation between what we see and what we know never will be settled.[10] The form-creating, image-making activities of human history are basic to this quest for a spiritual unity within the conflicting forces of our existence.

Part Two
Art Criticism
That Opens Us
to Meaning

Four

Seeing Whole:
Disorderly Art Criticism

We murder to dissect.
—William Wordsworth, "The Tables Turned"

Oh, look, said Dick. See Jane.

For many people, "look" and "see" were among the first half-dozen words they learned to read.

Vision not only precedes reading, it precedes language and (along with sounds and smells and textures) forms our earliest memories. Those primitive memories are not logical. They are an assemblage of superimposed and unsorted images, times mixed up, people and places interchanged. However, once we had reduced sight to language, we began to expect sensual experiences to make sense and find their logical sequence in our lives. Every creature acquired a genus and species, and our history became a time line. Perhaps this reduction of the senses to language and chronology explains why some people feel at a loss to look at art and find some meaning in it.

The present chapter will briefly sketch a theoretical base for the cyclical and sometimes disorderly method of looking at art

proposed in the coming chapters—a method that uses what is known about critical thinking, but also acknowledges our primitive responses and our natural inclinations as we approach a work of art. The method that best unlocks the spiritual content of art may, for many, resemble not a straight line but an interlace.

Art As a Riddle

Art is full of contradictions. At times it is dangerously absurd, much like faith. It does not make sense. Its basic nature is paradoxical: an artwork is a unity, a whole thing made of some material substance and yet transcending the material, engaging us simultaneously in a physical and a spiritual dimension. As such it exists in a seemingly infinite number of tensions, such as ontical and ontological, sympathetic and critical, private and public, expressive and impressive, to name only a few.[1]

So art is a riddle. So what? Maybe it is only meant to be experienced, not interpreted. Shouldn't we just let the art speak for itself? Don't we kill its spirit by taking it apart, analyzing it, putting it back together, subjecting it to questions and tests, claiming some degree of authority or at least integrity for our conclusions about it?

Why try to understand a paradox?

Artists ask these questions. So do students, ministers, secretaries, poets, salespeople, teachers, composers, actors, and dentists. Yet many of the very people who question the usefulness of art criticism have a desire to experience, through their interaction with works of art, some spiritual dimension locked within its form.

Measuring Halos

Perhaps one of the reasons for such uneasy questions about the analysis and interpretation of art is that the traditional critical process in art, as in any discipline, follows an orderly process that

may seem alien to the creative act. Certainly there are many approaches to art criticism, but one may distill them, as Feldman did, into a linear sequence:

Observe ➔ Describe ➔ Analyze ➔ Interpret ➔ Evaluate

The critic observes the art and describes it carefully, analyzes the form, studies the artist's life and the historical context, applies what has been discovered, and comes up with an interpretation that makes sense and a judgment regarding quality.

The Surface As the Beginning of Depth

Just such an orderly critical process has led a great many people to insights and enhanced their understanding of the human condition and even their relationship to God. The surface, it has been said, is the beginning of depth, and any informed method of art criticism creates the possibility of an encounter with the work's spiritual content. For one reason, critical thinking about art forces the viewer to stay engaged with the work, not to pass by or make judgments based on a cursory glance. The content cannot be separated from the form, and examining the form carefully may open at least the opportunity for some insight into the content. (Chapters 5 and 6 will describe some of these helpful reductive methods.)

Reducing Art

Even so, this kind of approach to art, however involved we become in the fact gathering and analysis, can obscure our view of the art's spiritual dimension if applied rigidly or as an end in itself. It becomes a bit like the art historian whose experience of medieval Madonnas had become a matter of measuring the evolving sizes of their halos.

Artists themselves often shrink at the prospect of reducing their works to so cerebral a method. "You can go to the moon or walk under the sea," said the quotable Picasso, "or anything else

you like, but painting remains painting because it eludes such investigation. It remains there like a question. And it alone gives the answer."[2]

The American artist Charles Demuth thought little of a strictly linear, analytical rendering of art. "Paintings must be looked at and looked at and looked at," he wrote:

> . . . they, I think, the good ones, like it. They must be understood, and that's not the word either, through the eyes. . . . They are the final, the nth whoopee of sight. A watermelon, a kiss may be fair, but after all have other uses. "Look at that!" is all that can be said before a great painting, at least, by those who really see it. . . . Only prayer, and looking, and looking, and looking at painting and—prayer can help.[3]

Disorderly Looking

But where is it written that art criticism has to be systematic? Order is not what makes art lovers love art, nor is a straight line necessarily the most fruitful distance between two points. In fact, the journey from apprehension to comprehension follows a serpentine path that circles and loops back upon itself, that brings you around to the beginning, like the endless interlacing tangle of line in a medieval manuscript illumination or a Persian arabesque (see chapter 5).

Art criticism that opens us to the spiritual content of the artwork is—like art making itself—often messy, approaching art as a whole thing and not a set of separate elements. It is not so much a linear progression as it is a tangle, an organic series of loop-de-loops, each reaching a deeper level of understanding.

It sounds like a lengthy and complicated process. But art criticism is only as drawn-out or brief as it needs to be. We may spin through it in seconds and pass on to other things (after all, not every artwork has the power to engage every viewer, not every picture can open us to meaning). Or we may spend a lifetime

coming back to a particular work of art, looking and looking and looking, always surprised by what we find.

Artworks that reach toward the depths of truth or suffering or joy do not yield their essence to the rigors of formal analysis alone. There is a point when we need to enter the work, or allow it to enter our own reality. For we perceive the literal, ontical facts about the work; but we are grasped by the ontological. We give in to the image, and it reveals itself to us.

The artist's labor may be an act of expression; it may also be an act of faith. But revelation is more than just expression; the art object itself will be a dead end, revealing nothing beyond itself, if there is no corresponding act of response in the viewer.

Timeless Spirit

Art criticism without such active response treats the work of art as an inert object, an artifact of the near or distant past. But the thrilling thing about art, that moves us and makes us mad and elicits laughter or lust or dread or a feeling of peace, that shows us who we are, is precisely that it is not a *fait accompli*. Unlike the history of events, in art the object of study is still present; it is as alive as the viewer. Its subject may be as current as this morning's newscast, or cast out of a set of beliefs and a culture we can no longer understand—but there is life in the artist's act of making and also in the viewer's act of responding.

Many times I have encountered students who, once they had opened themselves to a process of looking at art that was expansive and enlightening, found in it great significance for their own lives. They needed to recognize, of course, that they were placing their own cultural template upon the product of another age, perhaps an utterly different race, society, gender. The meaning they found may not register perfectly with the original intent. But neither does any other communication; the receiver's framework always imposes itself upon what is sent. (Even a simple declarative sentence by a man to a woman is likely to be heard

with a shade of interpretation that reflects her different upbring-
ing, beliefs, politics, and biology.)

I offer as a case in point the palm-sized Stone Age Venus of
Willendorf and similar figures, with pendulous breasts, pregnant
bellies, and inconsequential heads, arms, and legs, carved about
30,000 years ago. I can in no way place myself in that time or truly
know the significance of those small carved figures for their
makers or users. But there is something elemental in their solid-
ity, their round earthiness, the gravity of their breasts, even their
tiny size, that wakens in me a sense of the power of my own
femaleness and the wonder of procreation that even today—sur-
rounded by the antiseptic, stainless steel, technological efficiency
of modern medicine—new mothers are apt to describe as a mir-
acle. The real mysteries of existence are not erased by scientific
knowledge, which tells us how but never why. In art, the wonder
is left intact.

What passion there is in the face of the crucified Christ, dis-
torted with grief, on a medieval crucifix or a crucifixion painting
by Grunewald. Looking into that face, who can forget com-
pletely the tragedy of our existence? What intensity of feeling in
the mystic shrines of Michael Tracy, the pure blue horses of
Franz Marc, the sublime silent blackness of the Rothko chapel
panels, the gestural rhythms of a Jackson Pollock canvas.

Art has the possibility of opening to us, in visible form, mys-
tery. The first way to unlock the mystery, and unlock is not the
word either, is by looking and looking and looking—and by
entering into that mystery with our own creative response, and
being grasped by it.

Five

At First Glance:
Using Our Natural Ways of Seeing

Life is short, art long, opportunity fleeting, experience treacherous, judgment difficult.
 —Hippocrates, fourth century B.C.

Life is serious, but art is fun.
 —John Irving[1]

Friends often bring me cartoons about art. I pin them to the bulletin board above my desk and glance up at them when I need to smile. In one of these cartoons, of unknown source, a very tall teacher looming over his class of very small children announces: "Now, I'd like each of you to write for me what you *felt* when we were at the art museum."

It is ridiculous, we can see that, to expect people of any age to come up with a meaningful response—much less an understanding of it's disclosive Word—simply by sharing their feelings about art. Responding to art on a pure feeling level is equally

pointless if our response leads us to no further involvement with the work, no learning about it, no insight.

Members of a single group touring a modern art museum one November day made the following actual comments:

> I don't get it.
> My three-year old niece could do that.
> Is this a joke?
> I don't understand.
> It makes me want to reach out and grab it.
> It's scary; I don't want to look at it.
> You can't tell me *that* means anything.
> I love it, but I don't know why.
> What's the point?
> It's so confusing, you can't make anything out.
> Was the artist trying to make us mad?
> What is it supposed to mean?

Many people, when they confront visual images, respond immediately. "I don't understand" or "What is it supposed to mean?" lead the list of reflexive remarks. It is baffling or maddening to look at a work that obviously has the art establishment's *imprimatur* (or it would not be hanging in The Museum of Modern Art in New York or the Cleveland Art Museum) yet seems utterly devoid of meaning or worth. "Stared down by something that we don't like, don't understand, and can't believe in," writes John Russell, "we feel personally affronted, as if our identity as reasonably alert and responsive human beings had been called into question. We ought to be having a good time, and we aren't."[2]

Often no further attempt at understanding is made—no careful observation, no description, no analysis of the form—under the assumption that interpretation will be difficult or impossible, that the meaning of the artwork is an inaccessible

mystery. The viewer walks away disgusted, bewildered, dissatis-
fied, wanting more.

Many artists agree with Demuth (see chapter 4) that words
cannot lead to understanding of an artwork, that the only way is
to look and look and look. And they are right if we rely on words
alone. But learning how to look at and talk about art is part of the
hermeneutic task, that is, of interpreting what is observed.
Again, the content is inseparable from the form.

Natural Criticism

"Looking at art and talking about it" is a pretty good definition
of art criticism. Everyone is an art critic. The young man who
says "That's nothing but a blob of paint, it has no meaning, I
wouldn't give you five cents for it" has just committed three acts
of art criticism (description, interpretation, judgment). "I love
that painting, it looks so real you could reach out and touch it. I
can almost smell those oranges" is art criticism (response, analy-
sis, response).

"I like this one," said Margaret Thatcher in a 1998 BBC2
documentary on the *Secret Art of Government* as she gestured
toward a small, sleek sculpture by Henry Moore, "but I don't like
the big, lumpy ones."

The present chapter will not address the critical task of art
professionals—historians, reviewers, curators, and the like. It
will not be concerned with ranking or setting standards for qual-
ity. Rather it will introduce a way to see/think/speak about art
that takes advantage of our natural cycles of seeing and respond-
ing—beginning with the need to enjoy art and understand its
spiritual depth, with an attitude of openness, with a willingness
to wait, with just due given to one's spontaneous responses, and
with disciplined looking at the artwork before our eyes.

We glance
> we respond
>> with recognition shock laughter bewilderment
>> frustration delight

Our response tells us whether or not we want to linger
to come back
to see more

We look
> we discern purposes
> we respond
>> with understanding

Our response tells us how the art may or may not fit
our own needs at that moment

We observe
> we describe what we observe
> we respond
>> affirming or amending our earlier response

Our response tells us whether there is a reason
> to scrutinize the form

We examine
> we analyze what we discover
>> we break the surface

find visual relationships
learn how the thing was made
> we respond
>> with knowing recognition recollection
>> identification discernment

Our response tells us whether there is some reason
> to search further

We investigate
> the artist's life and ideas
> the culture of the times
> the influence of the past
> the impact on the future

we respond
> applying the artwork's genesis
>> to our own experience
> answering the artist's
>> expression with our own

Our response tells us if the art may have enduring impact
for our spirit

We look again
We interpret
We respond
We continue
We see.

Not that it is so tidy.

Not one of these acts can be separated from the others. Even at first glance we find ourselves describing, judging, looking for meanings, attempting an interpretation. The best thing to do is to go ahead—but to keep an open mind, knowing that early readings may change as the process continues.

Many who are frustrated and confused on their first contact with a work of art want to be less frustrated, want to understand.

Lacking a way, they go away.

Part two of *Image and Spirit* speaks to those people who want to discover a way to understanding. Some work will be required, but for every hill there is a chance to coast. It is also possible, as John Irving suggests, to have some fun along the way. Play, in fact, is an important factor in creativity . . . and that includes creative response to art.

Before continuing, be ready to make a record of your discoveries and reflections. Buy a journal and have it with you when you are looking at art. Not only does writing help to crystallize your thoughts; the physical motion of writing in longhand can release creativity and merge spatial with linear thinking. Such integration is at the heart of a method for interpreting art that allows us to apprehend and be apprehended by the visible Word.

Preconditions for Understanding

A few prerequisites exist even for the private, personal art critic. First, *become familiar with art*. Go to museums and galleries, read art reviews in the newspaper, look at books on the art that interests you, take in a painting or sculpture class.

Second, be as *inclusive* as you can be. This is especially important in our pluralistic age. Art of the past is never dead and it need not be old if it can be infused with new meaning; but to rule out the new is to overlook the sights of our own time, the visions of our own prophets.

Third, *temporarily suspend judgment*. Withhold your biases for as long as it takes to get involved in the work and let it begin acting for itself. This may seem impossible, particularly if you try to achieve that state of suspended judgment merely by good intentions. Biases and assumptions are so deeply ingrained in our ways of thinking and feeling that we seldom manage to recognize them, much less set them aside.

For example: The distinction between an image and the thing it represents is a culturally learned concept. We have seen that sculptural and painted images buried in Egyptian tombs were thought to function effectively in the afterlife. Four or five thousand years later, an artist visiting a remote African village in the 1950s was sketching cattle when a delegate from the tribe approached him and asked: "When you leave us, what will we do without our cattle?" In many primitive societies fetish figures were believed to contain the real spirit, as in a *minkondi* or nail

figure of central Africa, a sacred object with the power to heal or help people with their troubles; its power was released by pounding a nail into the image. Even today, voodoo practices persist in some parts of the world, such as Haiti, in which power over an effigy equals power over the real person or thing.

Active Silence

Once we are willing to acknowledge that much of what we assume to be true is culturally learned, we may approach the enigmatic object more openly. One way to accomplish this is simply to *wait* in front of a work you find disquieting. Active engagement with art does not necessarily mean the viewer is doing something. Silence may be the act required.

Here is yet another tension: a kind of active passivity, an openness, a willingness to wait for the visible Word to disclose itself. Only when we are apprehended by the artwork itself, with the total image and not just with the subject or the influences or the form, do we find our own inner voice and discover our own sense of the spiritual in that image.

The more difficult the artwork seems, the greater its potential for taking you beyond your habitual assumptions. It may be that nothing more will disclose itself to you, but at least there is a chance for the images to work upon your senses without conscious interference. Waiting—that is, exposing oneself to a work of art for as long a time as possible and, if possible, repeatedly—is one of several strategies that can be helpful at every stage of the critical process.

Sister Wendy Beckett, the widely-admired British nun who became famous for her enthusiastic, sometimes luminous interpretations of art for television audiences, was asked in a Public Broadcasting System interview: "If someone were to ask you how they could train now to see the art the way you do, what would you tell them?" Sister Wendy replied,

I would tell them to go to a museum and look at no more than two or three works, perhaps even two or three taken at random. Look at them. Walk backwards and forwards between them. Go and have a cup of coffee. Come back again. Wander around the museum. Come back again. Go to the shop. Buy postcards of them. Look again, and go home. At home, look at the postcards. Borrow from the library books on these artists. Go back again. Eventually you will find they open up like one of those Japanese paper flowers in water. You have to expend time and energy. If you don't want to do that, you can still get a lot of enlightenment and entertainment by just wandering around, but you'll never get the deep spiritual nourishment.[3]

Response

For some people, investigating and analyzing and explaining an artwork extinguishes that spark of recognition or insight or repulsion or joy, that charged moment when we see it for the first time. The initial response may have no basis other than one's mood, or taste, or an interest in the subject matter.

The initial response may be emotional. It is not unusual to feel anger, for example, or outrage. Or bewilderment. Pity. Delight. Even to turn away in indifference or laugh in derision is to respond.

Seize the First Response

It is artificial at best, even undesirable, to hold off responding to a work of art just because one has not dutifully toiled through description, analysis, and interpretation. Doing so may even serve to fossilize your reactions and send them underground so that, even while objectively describing and analyzing the artwork, subconsciously you are looking for evidence to justify your first impressions.

Don't look over your shoulder. Don't check with the experts. Instead, encourage your first response. Write it down, tell it, consciously think about it.

Let yourself go.

You can actually exploit your biases and your private frame of reference. Does the painting cause you to feel disgusted? Angry? Peaceful? Ask yourself questions about how you feel—even ridiculous questions, just to get the process going. Play up your emotions, state them as strongly as you can, choose inflammatory words—always being authentic but exaggerating just a bit.

Do you relish or abhor the tangled, rapidly applied strokes, splatters, and overlapping lines of a certain abstract expressionist painting? Does it remind you of a wild dance? Of viscera spilling out over the canvas? Say so! In your opinion, is that nineteenth century portrait of Christ vapid, banal, staged, sentimental, sappy, and tacky? Get out your biggest pen.

Subject and Technique

Often artworks that seem most accessible at this initial, surface-level encounter are the most naturalistic. They are recognizable and identifiable, and we readily respond to the subject matter and to the craft or technique. Neither is to be dismissed.

Subject matter is a key to the narrative aspect of a work of art. (Here narrative is used in the broadest sense, referring not so much to *anecdote* as to *experience*.) Our recognition of the subject may trigger a number of responses rising out of specific memories that involve those images; it may even have little to do with the artist's meaning.

It is not often that a response to the subject matter alone reveals the universal beyond the specific. Let us say you raise thoroughbreds, for example, and inevitably are drawn to artworks that represent horses. Your appreciation of the works may have more to do with the specifics of equestrian anatomy than with any symbolism or content the art may disclose. Yet images of, yes, horses have become moving spiritual figures, like Franz Marc's paintings of massive, curving *Blue Horses*—blue, to Marc, the color of the spirit. (Other colors, he wrote, "exist only to awaken the longing for blue.")[4] Or Deborah Butterfield's life-sized

horses—apparently constructed from twigs and mud and other natural materials but actually made out of such "civilized" substances as fiberglass, steel, or bronze—which bear a primitive and almost magical intensity, as if they had been unearthed from some ancient tomb and yet retain their life force. Or Susan Rothenberg's ephemeral horses running in an uncertain space (rain? snowstorm? outer space? fog? a cloud of dust?).

Technique, or *craft*, is another common arena of people's initial response to art. Whenever I ask a group of people to define art, several of them usually specify an activity that requires extraordinary talent or skill—"something not just anyone could do." They most admire works that are detailed, factual representations of objects in the real world; the better the forgery of nature, the better their approval. Even abstract paintings and sculptures are more acceptable to them if they are beautifully made objects.

Our admiration of craft also tends to yield specific rather than universal interpretations. Does it matter that an artist can make a painting look like a photograph? A portrait reproducing exactly the features of the sitter? A sculpture so lifelike that passersby and museum guards find themselves speaking to it? *It matters* if the artist is by this method exploring (for example) the nature of fact and illusion, if this is the artist's way of addressing the realities of nature or the human condition. *It is of no consequence* if the *how* becomes everything, obscuring or distracting from the *what,* if the work is no more than a showpiece for the artist's dexterity.

Technique or craft cannot be separated from idea. Art is an act of making, and the artist's use of materials is part of the whole (the unity of technique with idea), just as our bodies are part of our being.[5]

Most people with sufficient eye-hand coordination, patience, and motivation can learn the techniques of accurate representation. Craft in art has less to do with precision or technique than with integrity, with appropriateness of form to purpose or meaning. Fingerprints on a drawing, paint runs on a canvas, splinters

on a wood sculpture might be slipshod craft—or they might be intentional and essential elements of the work's image, conveyors of meaning. It just depends.

Whether the initial response is to horses or war or mountain peaks, to technique, or to color or texture or some other visual element of the artwork, those whose response draws them in for a closer look can use several methods to sharpen their visual perceptions.

These methods are reductive by definition, and using them in a mechanical way is not likely to advance insight, as chapter 4 pointed out. But the means discussed in this chapter and the next two have been chosen because they facilitate an openness and receptivity, a continued engagement with the work, and the opportunity to see more than one can observe at first glance.

First, or at some stage, it is useful to get a sense of the artwork's purposes. We gain nothing by judging a classical portrait for lacking the angst of a German expressionist face, or by dismissing functional works like a hand-hammered silver chalice or hand-woven stole as Low Art and therefore as unworthy of our regard. Identifying the art's purpose may come as a separate thought, or it may occur naturally as part of observing and describing what is seen.

Description

Inherent in the act of seeing is the act of describing. Consciously or unconsciously, to perceive any image as distinct from the infinity of images surrounding it is to describe it.

In writing or talking or even thinking about an art object we first note what our eyes detect—its physical nature. The visible Word, after all, is something seen. As an instrument of understanding, description needs to be careful, objective, and complete.

One might question the point of doing this, if enjoying art and discerning its spiritual meaning is our goal. However,

description is a valuable tool that supports the attempt to set aside prejudice, personal taste, narrow experience, and limited vision.

In its strictest sense, describing in the context of art criticism means not judging, not reaching conclusions, not interpreting, not even analyzing. In practice, this proves to be impossible. But avoiding qualitative statements also avoids the temptation to justify one's prejudgments about the work. In this way two people with widely differing reactions to an artwork might describe it in an identical way.

Methods and Tools of Description

So you're not much of a talker? Description, for the personal art critic, can take many forms. It does not have to be verbal or written, though most people will want to write and talk about art as they become familiar with it. I will list a few possible forms of description below.

Drawing. One of the best ways of describing is to draw what you see; in fact it may be preferable to verbal description, being more active. In order to make a mark the way Paul Klee made a mark, you will have to use similar materials, hold the charcoal or pen or brush like he did, work at the same speed and rhythm, see in the same way. Do not try to render the work in the precise shapes and proportions of the original; this will yield a dead imitation and will teach you little about the form. Try instead to make the marks with the same energy or limpness or nervousness or precision that the artist used.

Camera viewing. The camera has a special outlook that we do not have with our panoramic vision. It limits vision and therefore focuses on a portion of the scene. When you describe an artwork, you may wish to enhance your observation of its details by looking at them through a camera viewfinder or making a simple paper viewfinder to help you focus on one area of the artwork at a time. Simply fold a piece of paper in fourths, cut a tiny rectangle out of the folded corner, open it, and use it like a camera. Look not only for details, but also for relationships

between shapes and forms. (See Questions for Discussion at the end of this book.)

Silent description. A descriptive monologue or dialogue, when done internally, simply amounts to disciplined looking. In your mind, describe the artwork, listening in on the description so you can arrest any qualitative or subjective lapses. Or you can describe it out loud to another. Take a friend to an art museum; children are good because you have to be very concrete to hold their interest.

Private writing. Keep a journal for your personal art talk, as suggested earlier. In it you can draw a picture, write a poem or short story. You can record a description one day and go back later to analyze or decipher the work. You can read your reflections

Describe
Include only concrete, observable, and verifiable information about the artwork.
Label
Who: Artist's name
What: Title, size, and art form (painting, sculpture, film, etc.)
Where: Country or culture
When: Date or approximate date
How: Medium and techniques
Content
Subject matter (iconography): any and all recognizable images, beginning with the largest or most obvious, and increasing in detail

Art elements: types and qualities of lines, two- or three-dimensional shapes, textures, values, colors, and spaces

For the time being, restrict yourself to concrete observations of specific elements and do not analyze their use or effect.

from the past, agree or disagree with them, carry on a dialogue with yourself. Writing is both a tool to help you focus, and a creative act in itself.

The Descriptive Process

As you describe a work of art, *proceed from the general to the specific*. Identify the work—artist, medium, size, and so forth. Set the scene. Name the objects you recognize. Begin your description with statements you could make about most works of its type (a bronze bust, a collage, a landscape). Next describe what would be true of many similar works, then a few, and so forth, until you are describing what is utterly unique about this artwork. If you cannot name an image because it is unfamiliar or very abstract, use similes: "a red banana-like shape."

Be complete. Put in everything that may bear even remotely upon the other elements of the work. Of course some details will be truly irrelevant, such as the exact number of mountain peaks in the background of the *Mona Lisa*, but it may be necessary to describe them anyway until with practice you develop an ability to sort out the significant details from the unimportant ones.

Do not try to describe from memory. The visual memory of humans is notoriously inaccurate; several eyewitnesses to a crime, for example, will generally tell differing accounts of what they saw. Place yourself physically in front of the artwork—the original if you can. Looking and seeing are physical acts, and trying to work from memory makes them into cognitive acts, which encourage ideas and biases rather than vision.

Two techniques may be useful if you have trouble getting started with description. One, mentioned earlier, is *waiting*—giving the art object time to work on your senses. Take a few deep breaths, slow down, quit tapping your pencil against the edge of your notebook, don't look at your watch, forget what comes next. Just look.

The other technique is *questioning* (see chapter 7). The questions you ask do not have to be very good ones; their purpose is to give yourself momentum. What is the format: is it rectangular?

Big or small? What shapes do you see? What jumps out at you? What are the colors? Is there anything you don't recognize? What things look similar to each other? Is there a light source you can identify? And so forth.

Always keep in mind that we do not describe objectively simply because that's the way it is done, or because a teacher or a book tells us to. Objective description is a way to free ourselves as best we can from our biases and assumptions, for the moment at least, and to discover things about the artwork that we might otherwise have overlooked.

Description and Response

Description, whether explicit or implicit, is necessary to insight. A student who had some instruction and practice in objective description wrote the following brief response to an artwork by Georgia O'Keeffe:

> *Single Lily with Red*
> The colors used are symbolic of Christmas; the red of Santa's suit, the green of the tree, and, of course, the white snow. However, I am not left with a "Christmas feeling" after look-ing at the painting. Instead, I feel the chilly and uncertain feel-ing of death. The lily, which is symbolic of death, is presented stiffly against the cool green of the leaf. The background red seems to try to comfort the leaf, but to no avail.[6]

Even though description is not the purpose of this vignette, it is concrete, based on accurate observation. We have no trouble bringing the painting to mind. Accurate description, for the writer, was the beginning of an understanding response.

You may have been practicing some silent description as you have read these pages and looked at an artwork or two. Spend a few moments writing it down—now, if you can. If you have taken the time for careful observation, what you have discovered will almost certainly trigger some reaction or response. In a letter

home from Europe, Thomas Eakins—whose simple, clean, realistic paintings have an enduring appeal—responded in such a way to the Baroque painter Peter Paul Rubens:

> Rubens is the nastiest most vulgar noisy painter that ever lived. His men are twisted to pieces. His modelling is always crooked and dropsical and no marking is ever in its right place or anything like what he sees in nature, his people never have bones, his color is dashing and flashy, his people must all be in the most violent action, must use the strength of Hercules if a little watch is to be wound up, the wind must be blowing great guns even in a chamber or dining room, everything must be making a noise and tumbling about, there must be monsters too for his men were not monstrous enough for him. His pictures always put me in mind of chamber pots and I would not be sorry if they were all burnt.[7]

(So there!)

Eakins's words suggest that his observations were accurate and complete. It is doubtful that he ever developed an appreciation for Rubens—he makes no attempt at objectivity—and yet his emotional, subjective statements are concrete and visual.

On occasion you may find your opinions modified or mollified after describing a work of art. Try, as an experiment, to maintain your former view while writing your remarks in the light of newly discovered information about the artwork's visible form. Praise or find fault as you like, but *connect your statements to observable visual details.* Instead of saying, for example, "The old house looks haunted," as one student wrote of Edward Hopper's *House by the Railroad*, try something along these lines:

> The viewer's vantage point is below the horizontal strip of railroad tracks in the foreground. Consequently the tracks hide the base of the Victorian house, with its four-story tower, its

mansard roof and arched dormer windows. It seems cut off from a house's normal environment of grass, garden, and street, as if rising directly out of the tracks, sharp-edged against a blank sky, abandoned. Three or four half-open windows look like holes. Afternoon sunlight casts a deep shadow across the pillared front porch; no door can be seen where a door should be. No one is invited.

Based on this description, can you form an image of the painting in your mind's eye? Do you think you would be able to recognize it if you saw it in a book or a museum?[8] The visual details of Hopper's painting bear upon its possible meanings. It would take little exertion, now, to interpret Hopper's rendering of the old house as a metaphor for human emptiness and alienation, for the spiritual vacuum of isolated and unexamined lives. Other descriptions and other interpretations might come from different viewers—or from the same viewer at a different time— for what one sees in describing depends to a degree on what one is prepared to see. But whatever one's personal bias, it is necessary to pay attention to what is physically there.

Writing an essay is not the only form of descriptive response open to you. Perhaps you will tell it to a friend. Write it in free verse. Compose it into a few limericks or a short story. Write a letter to the editor about the artwork, if it is current and controversial.

Or simply meditate on what you see and what the image evokes in you. In response to *House by the Railroad*, for instance, I may reflect on those times when I protectively withdraw into myself like that old house; when I obscure all outside approaches to my inner world, self sufficient to the point of isolation. Might the lingering image of that abandoned house cause me even once to question the wisdom of my stubborn self-reliance? To rely instead on God? To become more intimately involved with other people? Such a response, rising out of description, moves me beyond form to the spiritual import of Hopper's painting.

If your description of a work has exposed little to hold your interest, a natural response now would be to skip it, turn the page, move on. Slip out the back, Jack. (It may be that you will return to it later, with renewed insight.) In our world there is a vast supply of truly compelling artworks to engage you, to stir you, to break through the surfaces of your experience, to reveal even as they deepen the mystery.

Six

Looking At,
Looking Around:
Formal Analysis

I mostly think of my work as the spoor of an animal that
goes through the forest and makes a thought trail, and
the viewer is the hunter who comes and follows the trail.
At one point I as the trail-maker disappear. The viewer
then is confronted with a dilemma of ideas and direction.
The possibilities are then to push on further by questions
and answers to a new place that I can't even imagine or
turn back to an old, safe place. But even the decision is
direction. I like this because as I make the trail I'm mak-
ing my own way and I'm finding my own forms. . . .
 —Ed Kienholz, 1977[1]

The trail left by an artist is no interstate highway, exits marked,
distances posted, destinations announced in advance, verifying a
map. Kienholz's metaphor of a forest more nearly describes it. If
not the spoor of an animal, then perhaps it is a trail of bread
crumbs, easily followed at first until, eaten by birds, it disappears
and the explorer faces the decision to turn back or find one's own
way. A glance at any artwork places us at the trailhead; as our

observations become increasingly inclusive and accurate, we plunge deeper into the forest. Somewhere along the way the choice to continue becomes a commitment. The wanderer becomes a seeker.

It is time to look more closely at the physical nature of the artwork—its *form*. The present chapter will include brief explanations of the basic elements of art, followed by discussion of six pairs of concepts that seem especially to lend themselves to a spiritual understanding of art.

Our desire to find the depth dimension, the hidden spiritual content in a given work of art (and I believe people overwhelmingly do seek this depth, whether or not they identify it as spiritual) is not well served by skipping or glossing over analysis of the art's form, however prosaic that analysis at first may seem, for that may result in careless interpretation.

Formal analysis is not always easy; but it is as much a doorway into meaning as *experientia vaga*—loose or mystical experience—as long as neither is ignored in favor of the other. To shun analysis is to damage the tension between form and content, to deal with the artwork not as a unity of matter and spirit but as a fragment.

Elements of Art

No doubt by now you have been able to describe a work of art objectively. In the process (whether you noticed it or not) you will have made some spontaneous observations about its formal elements such as point, line, shape, texture, value, color, and space. (Space will be dealt with later in our discussions.)

Point

A point is the smallest visual element, yet it may have a large impact on an artwork; try, for example, covering with your hand a tiny dot of color in an otherwise neutral painting. Stone's *B.P. (After Jackson Pollock)* includes a number of dots in graduated

KNOW THE ART ELEMENTS
Point
Large or small dots that contribute to the composition
Intersected lines or corners
Line
Types: straight, angled, or curved; broken, dotted, or continu-
ous; simple or complex; vertical, diagonal, or horizontal; etc.
Qualities: thick, thin, sharp, fuzzy, bold, delicate, textured,
smooth, orderly, tangled, etc.
Actual: implied (for example, line of sight, or a line interrupted
by a space or shape)
Shape
Two-dimensional or three-dimensional
Representational, abstract, or nonobjective
Geometric, organic, open, closed, solid, penetrated, clear,
indistinct, etc.
Value
Overall values: dark, light, medium, varied
Value contrast: high, low, medium, some of each; tints (color +
white) and shades (color + black); shading or chiaroscuro; etc.
Color
Color contrast: value (tints and shades), complements and triads
Palette or color scheme: monochromatic, polychromatic, analo-
gous or adjacent, complementary, primary (red/yellow/blue),
secondary (green/orange/violet), tertiary (red-orange/yellow-
green/blue-violet or yellow-orange/blue-green/red-violet), etc.
Color quality: warm, cool, intense, neutral
Naturalistic, arbitrary, or expressive color
Texture
Textural qualities: smooth, rough, hairy, scratchy, ridged, fuzzy,
wet, etc.
Actual (tactile) texture; visual (simulated) texture

Space
Two-dimensional artworks: spaces between shapes; spatial illusion
Three-dimensional artworks: spatial relationships; concave or convex volume, holes, or voids; spatial illusion (in addition to the real space)

sizes, a suggestion of perspective that subtly draws the viewer's eye into the center like crumbs marking a trail through a forest of vines. Crisscrossing lines and edges create points that attract or direct the viewer's eye.

Line

We use line when we sign our names; it is the basic stroke of most artists and is present even when made invisible, as in the smoothly blended surface of a photorealistic pencil drawing. A line is made by a moving point, and as such denotes movement: curved, straight, angled, diagonal, undulating, frenzied, rapid, slow. Line contributes direction and definition to artworks. Edges of things, or contours, are lines. Line encloses space to create shape. *Line qualities* are endless in their variety—wide, thin, fuzzy, sharp, scribbly, bold, timid. Lines can convey the full range of human emotions and sensations. (To get a sense of this, try writing your name as if you are worried, hurried, love struck, bored, nervous, angry, giddy, tired.) Lines do not even have to be visible to do their work; they can be implied, allowing the viewer's eye to continue the line's direction. How many different types and qualities of line can you see in *B.P. (After Jackson Pollack)*? Page through an art picture book now, and ask yourself how the artist uses line. What is its effect on the viewer?

Shape

Shapes are created by enclosing or filling two- or three-dimensional space; thus there are positive shapes (objects) and negative shapes (the shapes of spaces between and around objects). Shapes can be flat, as in Jasper Johns' *Target*, massive, as in a sculpture by Henry Moore, or volumetric, as in the interior of an ancient Mycenaean tomb. Like lines, shapes can be thin, thick, organic and irregular, geometric and precise, angular, soft, open, closed.

Our every movement changes the shapes we see. (See for example works by Marcel Duchamp or the Italian futurists such as Boccioni.) When shapes change, they change the negative shapes around them; often, negative shapes are as important to our perceptions of a scene—certainly to the composition of a painting—as positive shapes. Notice the importance of the spaces in most still-life compositions.

Texture

One element of visual art appeals to our tactile sensibilities, and thus draws us more completely into the experience of the work. Visual texture, as in a photograph of furry kittens or sun-baked mud, makes us imagine touching. Actual or tactile texture, as in earth sculptures or fiber art—and real, live furry kittens—makes us want to touch.

Value and Color

In art, value refers to a range of dark to light. It exists independently of color; a charcoal drawing, for example, relies on a range of values, not color, to be seen. However, all color has value. The dramatic pattern of a red and navy blue print, for example, will be difficult to make out in a black and white photograph because the two colors are very similar in value (both dark).

The use of color in art, and the relationships of colors to other colors, can be simple and straightforward, expressive and dramatic, or complex and intellectual. Look now through an art

picture book and see how many different uses of color you can find. Color is a product of light; note that your perception of color all but disappears in low light. White light contains the entire spectrum, and a prism (such as a raindrop or a crystal goblet) divides the spectrum into its component colors, resulting in rainbows. Pigments chemically affect a surface so that it reflects only certain colors of the spectrum back to the viewer. (Black pigment reflects no color, absorbing the entire light spectrum; white surfaces reflect the entire spectrum back to the viewer.)

The simplest tool for analyzing color relationships is a color wheel. Start with the primary colors, which cannot be obtained by mixing other colors: arrange spots of red, yellow, and blue in a widely spaced triangle. Add secondary colors to form a circle in the following order: yellow, orange, red, violet, blue, green, and back to yellow. Insert tertiary colors such as yellow-orange and red-violet in their logical spaces.

Mark the center of the circle. You may wish to draw lines from the primary colors directly through the center to their opposite colors (for example, blue to orange). Opposite colors are called complements because they have the effect of intensifying each other when placed in proximity of each other. Complementary colors often charge an artwork with energy; the edge between two complements may seem to shimmer.

Color schemes can be harmonious, as in adjacent or analogous color schemes; monochromatic (tints and shades of only one color); exciting, as in complementary color schemes or tertiary triads; basic, as in a primary triad; cool (greens, blues, violets), warm (reds, oranges, yellows), or neutral, in which most colors are mixed with some of their opposites or black.

Any exhaustive treatment of color theory would require a book in itself. However, most viewers have instinctive responses to colors and color relationships and easily discern the expressive or symbolic effect of color in an artwork.

Formal Analysis

Formal analysis is concerned with what we see, and with how the things we see are related to each other, including elements of art and design principles such as balance, unity, variety, emphasis, pattern, rhythm, movement, symmetry, dark and light, and color scheme, to name a few. In the process of analysis one encounters things that were missed in a first or second look, even in careful and detailed description.

Here is the place where most people turn back to the safe, well-marked path, for it is difficult (though not impossible) to analyze an artwork's form without knowing what to look for.

The following pages will not set out an exhaustive or technical background for the task of formal analysis. (See Further Reading and Resources at the end of this book.) They will review a few aspects of form that, in my experience, *clarify what is seen*, readily *submit to interpretation*, and often *convey spiritual meaning*. They also will focus on what is the most obvious and even the most *fun*.

The form of an artwork may be reduced to many categories for analysis; this discussion concentrates only on several paired concepts that are most likely to enhance our spiritual understanding of the work. Keep in mind that art talk is rarely neat. Almost nothing fits completely in one category or another, and in fact most artworks combine seemingly opposite qualities.

Abstraction and Naturalism

> **The aim of art is to represent not the outward appearance of things, but their inward significance.**
> **—Aristotle, 4th Century B.C.**

Naturalism, or the degree of factual resemblance to the real, surely is the most widespread popular criterion for judging art. It is also the most undemanding. A two-year-old child can look

ANALYZE
Similarities
Images that compare to each other in any way
Images that compare to other artworks, nature,
 or your experience
Differences
Color or value contrast
Marked contrast in scale, clarity, value, color, texture, or other
 elements within the artwork (see Know the Art Elements)
Noticeable differences from images in related artworks, or
 contrasts between the artist's depiction and nature
Principles of design
Abstraction and/or naturalism
Light and dark; contrast
Linear and painterly technique (applies to all of the plastic arts)
Open and closed shape, space, or composition
Balance and symmetry
Stability and movement
Rhythm and pattern
Unity and variety
Surface and illusion
Time and space

at a picture of her grandfather and judge whether or not it
resembles him. It takes no special gifts or training to know when
a painting of a violin looks like a real violin, when it looks dis-
torted, and when it doesn't look like a violin at all.

The painting of the violin is not, in fact, a violin.

That statement may have a familiar ring for the reader
who is acquainted with the works of the Belgian surrealist
René Magritte (1898–1967). His painting *The Treachery Of
Images* is a naturalistic depiction of a smoker's pipe on a plain,

white background—but written across the bottom of the canvas are the words *Ceci n'est pas une pipe.* "This is not a pipe." (What is it, then?)

What Is Real?

It seems safe to say that most artists of the twentieth century have dealt in some way with the relationship between art and the material world—that is, between illusion and reality. Henri Matisse once told of a visitor to his studio who exclaimed, "But surely, the arm of this woman is much too long."

"Madame," replied Matisse, "you are mistaken. This is not a woman, this is a picture."[2]

Other contemporary artists push the limits of virtual reality by incorporating real objects into their artworks. Not that they are the first to explore multiple levels of reality. In the seventeenth century, for example, Velazquez's famous masterpiece *Las Meninas* (The Maids of Honor) places the artist in the painting facing the viewer, presumably at work on a portrait of the subjects (the king and queen of Spain), who in effect occupy the viewer's position and appear in the painting only as a hazy reflection in a mirror on the far wall behind the artist. In fact, the whole composition very likely is a mirror image of the actual scene.

Surely a dominant spiritual concern in human life is the gap between what we know objectively and what we feel, between the tangible and the mysterious, between the real and the abstract, and in one way or another that gap has been a principal concern of art through the ages.

It's All Relative

Abstraction and naturalism are neither absolutes, nor, surprisingly, are they opposites. Even the most so-called realistic artworks are abstract in that they are not real, and most artworks exist on a continuum between very abstract and very naturalistic. This is even true of nonobjective paintings and sculptures that purportedly refer only to themselves and not to any outside

subject; Picasso, for one, believed there is no such thing as total abstraction, that all artworks are based in reality.

The Abstract Majority

The historian Arnold Toynbee has pointed out that, in the 30,000-odd years that people have been making images, few ages have demanded naturalism of their artists.[3] In fact there have been only two relatively short periods (relative, that is, to the other 29,000 years) when naturalism was a dominant style. One began with classical Greek sculpture in the fifth century B.C. and continued for about seven hundred years. The second period of naturalism bloomed in the Renaissance, came to full flower in the seventeenth century, and persisted until the twentieth century when it became only one of a number of options for artists in an increasingly eclectic age.

Naturalism for Its Own Sake

Any competent technician can learn naturalistic representation. It is relatively easy to seduce viewers with detailed and accurate images that copy nature but give little regard to balance or harmony in the composition—much less to meaning or spirit. At the other extreme, highly abstract works must succeed in terms not only of their composition and handling of the elements of design, but also their physical and spiritual presence; there is no recognizable subject matter to deceive the eye or distract from the work's emotional and spiritual essence. This was the view of Kasimir Malevich, and the reason behind the spare compositions of his suprematist period.

The Essential Image

Have you ever—perhaps at the first moment of waking—looked at something you could not recognize or identify? Something you saw only as shapes, colors, textures, dark and light? Sometimes a section of a strange hotel room, seen through partially open eyes, or an object viewed in the dim light of nighttime

will appear as nothing one can name. When eventually you realized that you were looking at some perfectly ordinary thing, did the view lose its mysterious attraction? Consider the possibility that, before the scene became identifiable, you were looking at the *essential image*—its abstract existence.

Georgia O'Keeffe is one of many artists who believed that there should be no separation of the naturalistic from the abstract. She wrote that representational painting

> . . . is not good painting unless it is good in the abstract sense. A hill or tree cannot make a good painting just because it is a hill or a tree. It is lines and colors put together so that they say something. For me that is the very basis of painting.
>
> The abstraction is often the most definite form for the intangible thing in myself that I can only clarify in paint. [4]

Andrew Wyeth, an American painter who is perhaps most widely admired for his faithful realism, also spoke of his paintings as abstractions. For many artists, the essence of an artwork is not what it represents, but what it *is*.

(For a useful exercise in understanding an artwork's abstract reality, in your journal or sketchbook make a diagram of a realistic work's main shapes, single or composite. Simplify—omit any details that make the subject recognizable.)

Methods of Abstraction

We may enhance our spiritual understanding of a particular work of art by recognizing the abstraction methods used by the artist. Doing so can help us as viewers to imagine or even recreate the *source* of the image and the artist's *process* of reinterpreting that source visually. The process of abstraction is a matter of changing the image in some way from its original.

Heading any list of abstraction methods is *simplification*, also known as *reduction*. Unnecessary details are stripped away. It may be only slightly streamlined; or it may be reduced to what

artists have called the irreducible form, unrecognizable to any who do not know the source. (The artist may not even remember the source.) In many cases, the process of simplification is in fact a kind of "essentializing," presenting only what in the artist's eyes is the heart of the subject. Early Cycladic idols, sculptures by Brancusi, the paintings of Marc Rothko are distilled to their essence.

Simplification is the most common way of abstracting images. Another is the changing of *relative size* or *scale*—done with sensuous effect in O'Keeffe's popular flower paintings, and with wit and high drama in the pop art sculptures of Oldenburg.

A great many artists—especially since the early twentieth century artists who freed color from its associative bonds—*alter color or value*. More abstraction methods include *distorting* shapes or proportions; *outlining*; *rearranging* the subject's components (often used together with truncating as in the analytical Cubist works of Picasso and Braque), and any other method of altering the image from its literal, real-life appearance.

As viewers we are drawn to what we can recognize, and representational art elicits memories and feelings with an immediacy that nonrepresentational art often cannot achieve. But the spiritual experience of art will be deepened for those who also learn to "recognize" images that do not correspond to ontical reality but to some inner vision. Francis Bacon wrote of his way of deforming the human subjects of his often-disturbing (some would say gruesome) paintings:

"I get nearer by going farther away. Any work that I like . . . makes me see other things. It makes me aware of reality, although it may not be very realistic in itself. I can only put it that way—that it unlocks the valves of sensation."[5]

Light and Dark

Light reveals what is hidden. It dispels darkness, both literally and symbolically: we speak of enlightenment, light of lights, casting light on a subject, the light at the end of the tunnel, a smile that lights up a room.

A few years ago my husband and I toured a ghost mine in Bisbee, Arizona. We put on yellow slickers and miners' hard hats, climbed onto uncomfortable rail cars, and rode into the heart of the mountain. One mile deep, as the group stood shivering in a room of the old copper mine, our guide turned out the lights. Instinctively we grasped each other's hands. We felt something eerie, unlike the darkness in one's room at night or the blue-black of a moonless night. In total absence of light we could *feel* the darkness; it materialized into a kind of pressure that we could feel against our skin.

Only rarely do people (even the sightless) experience such total absence of light—nor, for that matter, the total absence of darkness. Without light there is no sight and therefore no visual art. But anyone who has overexposed a photograph knows that light depends on darkness to make things visible. Shadows imply light and delineate form.

In the Renaissance, Leonardo da Vinci and other painters developed the art of using light and dark to give an illusion of three-dimensional form—a method known as *chiaroscuro.* Transitions from dark to light lent to their figures a sense of sculptural mass. By the seventeenth century artists such as Caravaggio, George de la Tour, and Artemesia Gentileschi were playing bright lights against deep, absorbent shadows that gave their works a dramatic presence and made their subjects seem to advance toward the viewer out of the blackness of the background. The artist's *method of illumination* may be significant. Is it a cold light or warm? Diffused? Direct? Strong side light affects the perception of three-dimensional form differently from frontal light, or overhead light or back lighting. Look around you—hold a flashlight up to your face—and observe

light's effects on the objects you see. Find several works of art in which light plays a central, dramatic role and imagine how the work would be changed without it.

Uses of Light

Light is one of the most versatile and expressive elements of visual art, and its various uses contribute to our understanding of the image.

Symbol. Artists have turned again and again to light as a symbol for every shared human experience. Medieval artists used a symbolic light (the halo) to denote holiness. Vincent van Gogh used light to symbolize inner torment, the turbulence of the universe, hope alternating with despair, the all-seeing God. The lamp above his 1885 *Potato Eaters* unifies the destitute family group in its warm light. In *The Night Cafe* of 1888 a strikingly similar lamp appears, a relentless eye-shaped light leaving no dark corner in which to hide. In his famous *Starry Night* of 1889, the sky is alive; it swirls around the brilliant stars in a cosmic embrace and the radiating emanations are turbulent, charged, perhaps even celebratory.

Later, a similarly eye-shaped light appears in Picasso's *Guernica* as the exploding bomb above the panicked city below. In *Guernica* the brutality of human nature is laid out in harsh cold light and angular black shadows. Is there no hope? Perhaps, though weak, hope resides in the lighted candle, held out in a victim's hand, visible even in the horrific glare of exploding bombs.

Another kind of symbolic light is the recurring motif of the setting sun in many works by Edvard Munch, such as *The Voice* and *The Dance*. The sun, joined with its reflection in the water, becomes a glowing, pulsating figure that stands on its own as a tangible object, dagger-like, hot. Such an intensely personal and mysterious symbol is not easily explained in words, but it is forceful and alluring. Many see in this apparition danger, others hope, still others despair. The following paragraph comes from an

unsigned short story by a student who had studied and described *The Voice*:

> I began to paint: A woman walking into a forest of darkness, leaving the warmth and peace of the beach. The woman is my mother. Death is buried in the sand, but she can see its eyes and hear its voice. In the boat a photographic image, good and evil together, judging my mother's actions as she leaves this life. The sun is an enormous holy cup, the presence of God unable to stop her, but accompanying her as she steps into the unknown. [6]

To this viewer the symbolic light in *The Voice* was a key to a spiritual interpretation of the painting, an illuminated glimpse into that oft-rehearsed and feared and inevitable moment when one must pass out of this life.

Emotion. Dark, dimly lit scenes surely carry an emotional impact that is quite different from warm and sunny views or gray diffused light or the bright high contrasts of spotlights. The emotional or psychological tone invoked by light and dark is one of the most readily interpreted uses of light, for we feel its effects in the landscapes and interiors of our daily lives. In Francisco Goya's etching *The Men in Sacks* (from the Proverbs series), a dark landscape is peopled with men in a variety of anguished poses, all of them enclosed up to their necks in huge, luminous white sacks. The whiteness of the sacks and the darkness of the landscape emphasize the men's predicament—bringing to mind loss of freedom, frustration, a trapped feeling, the common nightmare of needing to run but being unable to move one's feet.

Mystery or transcendence. Light always has carried mystical connotations in art. From Rembrandt and earlier, to van Gogh, Munch, Pollock, and the present day, painters have used light to show the soul behind the features of a human face, the divine presence transcending the material features of earth, the sublime and uncontrollable side of nature.

Drama. A high contrast between light and dark, in any art form, has a dramatic—even theatrical—effect, as in Goya's *The Men in Sacks.* The images confront us boldly. Baroque painters such as Caravaggio and Gentileschi placed their subjects, it seems, on a stage that is lit by footlights. The lighting suits the melodramatic tales told in their paintings—tales such as the conversion of St. Paul or Judith beheading Holofernes.

Subject. Occasionally artists have turned to light itself as a subject for their work. It may be a focal point in a painting, or the work may be an investigation into the very nature of light and sight. Impressionist painters such as Monet concerned themselves with the optical effects of light itself. Some architects not only manipulate light but also make it an essential element of the structure, the focal point of the visual space. Color is, literally, light; "color field paintings" that have no recognizable subject matter but glow with luminous hues have not only color but its parent, light, as their subject.

There is something so primary about light that its use as the subject of art almost inevitably produces images that are spiritually felt, that for the meditative viewer are doors into a spiritual "space" much like the mystical light-filtering doorway in a kiva (a ceremonial place of the Anasazi and their descendants, the Pueblo people of the American southwest).

Along with all the other ingredients of the analysis of form, as soon as we begin analyzing light in an artwork, interpretations occur to us. The analysis can be a fruitful opening into understanding of a certain spiritual depth, as long as we do not resort to measuring halos.

Linear and Painterly Technique

The manner in which paint is applied to a canvas, or graphite to a sheet of paper, or even clay to a sculpture, bears surprisingly upon its spiritual content. For simplicity's sake, the endless varieties of mark-making techniques may be reduced to two categories, *linear*

and *painterly*. Few artworks are purely linear or entirely painterly; most combine both approaches but favor one or the other.

The *linear* technique results in definite edges (sometimes even outlined), sharp focus, and shapes that are clearly distinguished from each other throughout the work. It is a controlled and often precise approach. In linear paintings or graphics, *chiaroscuro* may be used to indicate three-dimensionality, but edges of shapes are demarcated by a line or by a crisp, definite change in value or color, as in the Renaissance works of Bellini or the twentieth century paintings of Hopper.

In contrast, the *painterly* technique has visible, often thick brushstrokes, or a surface that reflects the mark of the artist's hand. Most of the shapes are not clearly delineated, particularly in the shadows where they tend to blend together. It is a looser, more gestural style, with relatively soft focus. The paintings and prints of Goya, van Gogh, Lee Krasner, and Pollock are good examples of painterly artworks, as are the works of recent neo-Expressionist artists. These categories can be applied metaphorically to other art media, such as sculpture, photography, and even architecture.

Technique concerns the handling of the surface. What difference is it to the spiritual content of the work whether an artist makes marks in a very precise or controlled way or in a loose, soft, gestural manner? Whether a sculptor produces a smooth, clean finish and hard edges or a rough, textured surface that clearly show the manner in which it was made?

There is a difference. Mark-making is an essential, irreducible act of plastic art ("plastic" in this sense referring to the physical manipulation of a medium or substance to create the image). An artist's own way of making marks is not possible to plan, teach, or contrive. The mark of your hand reflects your rhythms and your energy—some believe your very personality and character. Those unconscious marks which flow naturally from one's being—whether controlled or loose—make up the concrete visual language of the Spirit as interpreted by one person.

Open and Closed Form

"Body language" is a good way to picture open and closed form. When you stand with your legs together and your arms folded, you are a closed form. If you put one foot up on a rock and spread your arms to the sky, you are an open form. Many people have observed how much we reveal to others through our open and closed body language. An open form is pierced by space. It also changes the shape of the space around it. Closed form is monolithic, contained. Once again, the concept not only is attributed to painting, but is a meaningful clue to the understanding of any visual form.

In painting, the arrangement of visual elements is called the composition. *Closed compositions* are controlled by the frame; the important images are more or less enclosed by the edges and often repeat the shape of the frame. Usually verticals and horizontals dominate. Often the work's main subject is centered on the canvas. Early Renaissance painting and medieval icons generally have closed compositions. So does Jasper Johns's *Target* (the image being just what the title implies), and a multitude of other old and modern works.

Open compositions involve the viewer in the space, because the scene seems to continue beyond the frame. It is like a window: we are made aware of the continuing image beyond. Baroque artists discovered the enlivening capacity of the window space, giving their compositions a presence that the closed formality of Renaissance composition could not achieve. Late nineteenth century Impressionists such as Edgar Degas were among the artists influenced by Japanese prints to "break out" of the rectangular frame and boldly truncate the foreground images at the corners of the frame.

Beyond painting: Henry Moore took the openness of his abstract stone figures a step further, piercing them with a *hole* which to him had significance; he wrote that the first hole made through a piece of stone is a revelation akin to "the mysterious fascination of caves in hillsides and cliffs."[7] In this regard it is

hard to miss a striking relationship between Moore's holes and the hole in Noguchi's *Red Cube* described in chapter 3.

Neither open nor closed form is more profound or compelling or persuasive than the other. Involving the viewer in the space (or not) surely affects the image's impact. But beyond that, an open form may speak in general to the lack of control in human life, to uncertainty, to adventure, to flux, to change, to possibility. The closed forms of Egyptian sculpture disclose the stability of that enduring culture. Closed form may also be used to express self-protection and vulnerability, as well as distance, calm, peace, stability, endurance, safety.

We currently place a great value on openness—to be an "open" person is thought preferable to being "closed"—yet much of life is closed to us and we cannot (contrary to popular wisdom) do or be anything we want to be. Large portions of our days are lived by formula. We follow routines. We feel we have little control over the course of human events, and what freedom we enjoy exists within a narrow range of options. Our physical and spiritual lives are at once open and closed . . . and the complexity of these interactive states may be embodied in the open and closed forms of an artwork.

Inseparable from open and closed form are the principles of *balance* and *symmetry.* Closed compositions usually are formally balanced, perhaps even symmetrical, with a central image and roughly equivalent weight along the vertical axis. The vast majority of medieval artworks (and many Renaissance works as well) are formally balanced. Some are rigidly symmetrical. Their symmetry may be the result of their format. Frescoes were contained within symmetrical architectural elements. Altarpieces and personal icons came with folding side doors to protect the central painting, dictating a formal arrangement of pictorial elements.

Informal balance and open composition are nearly synonymous and have characterized much of art from the Baroque Age to the present. The subject of the artwork is not necessarily in the center; for example, Tintoretto often placed his key subjects off

to the side or even in one corner of a huge canvas. Informally balanced compositions are dominated by diagonal lines and movements. To say a work is informally balanced is not to say it is unbalanced. Often, for example, you will see an image or shape in one corner of a canvas balanced by another image of similar visual weight or visual interest in the diagonally opposite corner.

Stability and Movement

The concepts of stability and movement are inseparable from open/closed composition. Calm, order, rest, meditation, and silence are the essence of stable compositions; they have little movement and divide space primarily into verticals and horizontals. Movement, or dynamism, employs complex curves and diagonals to express action, restlessness, energy, excitement, chaos, noise.

Many artists seek to combine both stability and movement within a single work. *Triangulation*, in which images are arranged to form a triangle or pyramid, is one of the most used methods of achieving this active tension. The base of the triangle is stable (try tipping over a Pyramid of Zoser!), while the diagonal sides convey movement. Artists may use triangulation in an open form or in an open arrangement of several forms so that parts of the triangle are only implied, and even more movement is achieved within its inherent stability. Beckmann uses triangulation with a heavy hand in *Family Pictures* without subtracting anything from the action and emotion.

Artists also create movement within an artwork while preserving order through *rhythm* and *pattern*. The repetition of lines, shapes, colors, or motifs—whether in a regular pattern or irregular arrangement—calls forth our inner sense of rhythm and the natural rhythms of nature. Do you ever hear music in your head while you look at an artwork? What are its rhythms? Looking at the works of Abakanowicz, I hear Sibelius; in Chagall I hear tambourines and accordions; in Kandinsky, jazz.

The perceived requirement for both stability and movement within artworks may reflect the human need for stability and movement in our daily lives and our spiritual existence. Not to grow is to die—but to grow without check, like cancer cells, is perilous. Change needs to be weighed against enduring values. Not all change is good. A painting or sculpture or photograph that achieves an equilibrium between stability and dynamism may embody not only the need for certitude, for the unchanging presence of God in private life and human affairs, but also the ever-changing character of our relationship with the unknowable, a movement of the Spirit, growth in relationships, mountaintop experiences, and deserts of the soul. Stability *and* change are in the nature of our humanity and our spiritual life, and to stress one over the other is to upset the balance of that life.

Unity and Variety

Unity and variety seem to flow from stability and movement. The unity or harmony of a work of art allows the viewer to perceive it as a whole; it is "readable" in a visual sense. Without unity the work would be haphazard. Variety is the counterpart of unity; it ensures that there will be something there to hold the viewer's interest. Aesthetically most artworks require both unity and variety, though not necessarily in perfect tension.

One way of achieving unity is by *repetition* of some visual element, such as the triangle of the piano lid in Max Beckmann's ominous *Family Picture*, painted between the two world wars. Resembling a Gothic peak, an obelisk, or a bomb, the shape is repeated in the wife's topknot, the mother-in-law's hairpiece, the sister-in-law's reflection on the pink wall, the angle of the screen, the kite, and in negative shapes and shadows throughout the picture. As in Vincent van Gogh's *Potato Eaters*, the lamps resemble eyes—especially those of the artist and his sister-in-law as they stare vacantly into space. The soles of Beckmann's shoes echo the candle flames. The plant up in

the corner is not a hopeful, living thing (like the small flower in Picasso's *Guernica*) but a big, scary black spider. Did Beckmann see into Germany's horrific near future? Did he use images of his own family—held in a stifling unity despite the chaos of their crowded room—to connote the unwillingness of the German people to alter their habit of obedience?

Such images, that look similar to each other or to something outside the artwork though they have nothing else in common, are called *visual metaphors*.[8] Looking for visual metaphors can be almost addictive. Artists know about them and use them either consciously or subconsciously; some are coincidental, but many are not. Notice again the eye-like shape of the exploding bomb in Picasso's *Guernica*. In *Chalice*, the artist selected a section of flagstone patio because of its resemblance to a footed cup. What visual metaphors can you find in an artwork of your choice? Searching for visual metaphors is a fascinating way not only to see the artwork's unity, but also to uncover symbols, relationships, and hidden meanings.

Other unifying methods are *proximity*, wherein different elements are grouped together to form a larger, composite shape, and *continuity*, in which shapes or marks are placed to lead the eye along a particular path. Beckmann also uses these methods. Vincent van Gogh's five family members in *The Potato Eaters* are ranged in a continuous circle that holds them and draws the viewer's eye into the circle. In fact, artists use proximity and continuity almost unconsciously, so that you will be able to find examples of these methods throughout the history of art (and surely throughout this book).

Works that express excitement and energy, or restlessness or chaos, inevitably place an *emphasis on variety*—for example the 1990s prints and relief paintings of Frank Stella, Michael Tracy's *Cruz de la Paz Sagrada*, and certainly Beckmann's *Family Picture*. Artworks that are meditative and still, that invite a calm and reflective response, as do the works of Rothko, Malevich, nonobjective painters and sculptors of the past fifty years, and spaces

such as the Kivas of the Pueblo people, place an *emphasis on unity*. Without unity the work falls apart visually. Nothing can be made of it. However, without variety there is no visual interest, nothing to hold our attention.

The ideal is *unity within variety*, the use of diverse elements that nevertheless work together as a coherent whole. Once again *Family Picture* and *Guernica* serve as convenient examples. There is plenty of variety—in fact the viewer needs time to discover everything that is going on—but both paintings are tightly unified, contained, whole. That very containment is essential to their meaning.

The tension between unity and variety can be seen as a metaphor for the realities of our spiritual existence. We crave diversion and excitement; boredom saps our energy and kills love. Yet there is a whole, somewhere in the depths of our existence, a way to make some sense of the fragments of our lives. Artists, like the rest of us, sense and seek that unity.

Surface and Illusion

Virtually all two-dimensional artworks involve some inherent illusion of depth, or spatial illusion, just as three-dimensional artworks involve actual depth. Even a single mark on a white sheet of paper will activate the surface so that the mark seems to advance toward the viewer, however slightly, while the white space becomes background. (Try this now, and observe the change.)

Throughout history, artists have attempted to present to the viewer images that are congruent with the way they see. In doing so they have incorporated various degrees of spatial illusion in their works. Their methods reflect observable relationships between objects as they occupy space.

Overlap

We know, whether or not we take note, that most objects in our world are not transparent, that if I place my hand in front of my nose it obscures your view of my face. Artists with even the

slightest concern for representing objects in space have used this method of spatial illusion. But prehistoric people who painted horses and bison on their cave walls seemed to have no such concern; their remarkably naturalistic line drawings are superimposed upon each other with apparent disregard for any relationship among them. Egyptian painting also shows almost no regard for spatial illusion. Subjects are depicted *conceptually*, with little or no overlap, so that a painting of a pond in a garden shows all sides of the pond equally; trees and other objects that in a pictorial space might overlap each other are folded back along the sides for maximum visibility.

Overlapping shapes do not have to be recognizable to create an illusion of depth; even abstract and nonobjective painters create illusionistic space by placing shapes over shapes.

Relative Size

How is it that Beth, who has only one good eye, can safely drive a car? She can because of a second and slightly more sophisticated observation about objects in space: that closer objects appear larger to our eyes, and distant objects appear smaller. The distance of an oncoming car can be judged by its relative size; what we call "depth perception" is not absolutely required.

Artists have not always sought to show distance through size relationships. The Egyptians often depicted the sizes of subjects in hierarchic proportion, according to their relative importance rather than their relative positions in space. In medieval painting, angels, saints, and donors or patrons routinely appear considerably smaller than the Virgin. Even as late as the fifteenth century a few artists painted important figures too large for the rooms they occupy; in Fra Angelico's famous *Annunciation*, if Mary were to stand up she would crash through the ceiling.

Ever since the Renaissance we have seen relative size used consistently to create a sense of depth in painting; it can be exaggerated for even greater depth, with foreground images increased in size and background images made smaller than

they would appear normally. This method applies in sculpture as well; Michelangelo, for example, took into account the viewer's perception of relative size when he created his famous fourteen-foot-tall *David*, making the head disproportionately larger than the body so that it would appear natural when viewed from the ground.

Location on the Picture Plane

The picture plane is the two-dimensional surface of a painting, photograph, drawing, or print. To picture this method of spatial illusion, look at any real scene and imagine you have taken a photograph of it. Notice that objects below your eye level will rise on the flat surface of the hypothetical photograph as they recede into space. Objects above your eye level, such as clouds or light fixtures, will appear lower on the picture plane as they go back.

This principle requires some thoughtfulness to observe and, with the exception of Western art in the past five hundred years, we do not see it used consistently through the history of art. Children, for example, tend to range below eye-level subjects along the bottom edge of their paper and above eye-level images along the top edge. Those youthful artists view space not illusionistically but, like the Egyptians, conceptually—as it exists in the mind. It is a matter of intent, not of a right or wrong way to see.

Detail

We know well our limitations in seeing details at a distance. Trying to read the signs above the far end of a supermarket aisle makes this annoyingly clear to me.

But art is not bound to physical laws or the limits of our vision. It is quite possible, if the artist wishes, to fill an artwork's background and foreground alike with abundant detail. A folk artist like Grandma Moses might paint every brick on the chimney of a farmhouse that, by its other spatial relationships, appears to be at least a mile back in the scene. An artist wishing

to create a sense of believable three-dimensional space, however, will restrict detail to the foreground and simplify images as they recede.

Value

Light and dark values can be manipulated to increase the viewer's experience of spatial depth in an artwork. A dark foreground, where the viewer seems to occupy a cave-like space and the distant view is illuminated, is as effective as a light foreground and dark background. The important thing is the *contrast* between light and dark.

Color

Color can be used in two ways to enhance the illusion of depth. One is its *"temperature."* If you have ever driven across the plains toward mountains in the distance, you will recall that the mountains appeared cool at a distance—violet and blue-gray—but as you entered the foothills you saw their actual colors, warm earth tones of brown, rust, tan. Painters may choose to exploit and even exaggerate color temperature to enhance spatial illusion.

Color *intensity* also may be used to create a sense of depth. Intense colors are pure colors. When they are mixed with some combination of black, white, or their opposite (a bit of green mixed into red, for example, or orange into blue), colors are *neutralized* and appear to drop back in space. In general, both color temperature and color intensity are less obvious tools for spatial illusion, and usually are employed together with other methods.

Perspective

Before the Renaissance, there was no systematic way for painters to depict a believable illusion of deep space. From the fifteenth century onward, artists employed a method for drawing or painting a scene from the frozen vantage point of a single onlooker. This organized system, generally attributed to the architect Brunelleschi, is known as *linear perspective*. It is a geometric

method that uses horizon lines, vanishing points, and working lines. The single vantage point made it possible for two-dimensional artists to paint a scene illusionistically. Their figures began to occupy a believable three-dimensional space, rather than crowding up against the picture plane in an arrangement that was more conceptual than natural. Now the viewer of the painting is the imagined onlooker, hence the sense of presence one feels in an illusionistic painting.

Perspective is important to the art's meaning when a deep space is part of the "story," as in most cityscapes. The single viewpoint is important in terms of *point of view* (see chapter 5), and when the artist plays with the viewer's vantage point. The single viewpoint in a sense epitomized the worldview of the Renaissance, both literally and spiritually. It revolutionized painting, but also to a degree limited it. Ever since, we take the fixed viewpoint so for granted that we assume this is the only way we see.

It is not.

We see the world around us in three-dimensional space and in movement. No object in our environment is completely static to our eyes. As you tilt your head or shift in your chair, you see a changing view of this book. Turning the page reveals myriad planes of your hand. As someone walks through the room, you see that person from many angles in a few seconds. As you walk down a street, what you see moves with you. Except for brief periods of immobility, our vision is dynamic, fluctuating, complex.

Early in the twentieth century, many artists recognized and acknowledged the complex reality of the way living people see. Perhaps the importance of this trend was that it expressed the modern view of the world and of humans as unpredictable and permeable—in contrast to the fixed and unified viewpoint of the Renaissance. The need to accept and deal with ambiguity, with change and its attendant loss, seems to characterize the spiritual journey of twentieth century women and men.

Time and Space

Time and space are not tensions but essential and interdependent elements of vision. Many artists have tried to separate time from sight in their works—to "freeze" time, as it were. But we cannot separate our view of the world around us from time. Visual art is spatial, but our view of it, and of everything else, is spatial *and* temporal—that is, we experience it in space and time. We may glance at it for a few seconds, or spend hours examining it.

All sculptors must work with the element of time, for the artworks change as viewers move around them.

The Cubists opened the twentieth century, as we have seen, with a rejection of the fixed viewpoint and the restoration of time as an essential ingredient in art. Arguably the first and most important artist to do so was Pablo Picasso. The viewer is no less a part of the space than in a fixed-view illusion—but now is invited to walk into the space, as it were, seeing the subjects from different angles as one would in real life. Look again at Beckmann's *Family Picture*. The influence of Cubism, whether direct or indirect, is visible in the multiple viewpoints, the angularity of the figures crowding to occupy the same shallow space, the importance of eyes (though only the wife meets our eyes). Such paintings are hard to like; they force our involvement and extend the element of time by abandoning the fixed viewpoint and drawing us in.

Space and time are not just interrelated; they are inseparable. Margaret Atwood begins her novel *Cat's Eye* with a visual image of time that relates it to spatial perception:

> "I began then to think of time as having a shape, something you could see, like a series of liquid transparencies, one laid on top of another. You don't look back along time but down through it, like water. Sometimes this comes to the surface, sometimes that, sometimes nothing. Nothing goes away."[9]

Atwood's image suggests that, just as all space exists in the dimension of time, time exists in the dimension of space. The

superimposed paintings in Paleolithic caves of France and Austria, as well as petroglyphs made by early residents of the Americas, telescope time. The prehistoric image of a bison is still visible beneath other images painted hundreds or thousands of years later.

Whenever we view an art object, time goes by. As we pass that time viewing its surfaces, they draw us into its space. Remember that even a single mark on a white sheet of paper creates a sense of depth. This *activation of the surface plane*, regardless of whether the artist goes on to attempt an illusion of three-dimensional space, is the most elemental method of spatial illusion and may also be closest to its spiritual depth.

Medieval art, for example, and especially manuscript illumination, is all about the activated surface plane. In the seventh century *Book of Lindisfarne*, the *Book of Kells,* and other medieval illuminated manuscripts, we see an intricate interweaving of line, a complex and interlacing surface. In such surface art there is different variety of depth that reflects the infinity of space better than any fixed viewpoint rendering of a scene can do. The "Celtic interlace" has no beginning and no end—or rather, like the tangled forest trails we have been following, it brings us back to its beginning.

Another kind of interlace can be seen in the twentieth century works of abstract expressionist artists such as Krasner, Pollock, Tobey, and others. Here again the surface is everything; there is no mass, no horizon line, no illusion of three-dimensional pictorial space. Yet, just as Dixon wrote about the Celtic interlace, it does not work to say of such art that there is no space: "The line as interlace is infinity, itself a transcendence. The interlace is a screen, a delicate, rhythmic, flowing screen. A screen is between us—and the infinite emptiness, the empty infinity beyond."[10]

The literal space is no deeper than the infinitesimally small distance between a mark and the one it overlaps, yet due to that very layering of marks there is a sense of cosmic depth, of endless outer or inner space.

Artworks with transparent layered images merge space and time. Duchamp's famous (once infamous) *Nude Descending a Staircase* involves time almost literally, mimicking motion pictures by layering various stages of the model's movement and thus showing us the entire descent in one frame. Pollock's *No. 1* is a web of layered lines and shapes. Frank Stella's recent works superimpose multiple images, such as abstract shapes, gestural line, rendered smoke. None of this depth is illusionistic; like the Celtic interlace and the works of color field painters, it is the real depth of many stratified lines and shapes; but curiously these works put one in mind of another infinity: the boundlessness of space and time, and God. No walls, no horizon lines limit our sight or bind us to the curvature of the earth, the perimeters of our rooms, the view of a frozen moment, the distance our eyes can see. The forest trail and the interlace open up to infinity.

Seven

Looking In, Looking Beyond: Interpretation

It is impossible to see a whole tree; a tree actually lives
underground as much as above ground.
—Kimio Tsuchiya[1]

What does it mean?
What does it mean?
What does it mean?
—Three anonymous viewers,
overheard in an art gallery

The most complex task of a spiritual understanding of art has by
now the least to be said about it, for in our disorderly way we
have been interpreting as we go.

Interpretation has been defined as "a process of finding the
overall meaning of a work that the critic has described and ana-
lyzed."[2] But the interpretation of art does not submit to so nar-
row a range of operation. In some instances interpretation may
never occur as a discrete act in looking at and talking about a
work of art. During description and analysis—perhaps even at

INTERPRET

The following are suggestions for interpretation, not rules; use as you see fit, and in any order that naturally occurs.

Question

What do I feel when I look at the artwork?

What is the overall mood?

What seems important?

Free-associate

What does the image bring to mind?

No rules: let your mind wander where it will.

Compare and contrast to other artworks.

Investigate the historical context if you feel it will inform your interpretation.

Eliminate and **arrange** your previous observations:

Eliminate the unimportant or uninteresting.

Arrange potentially significant observations
in any order you like.

Suggest meanings the artist may have had in mind.

Test your ideas: review your description and analysis.

Reflect on spiritual and personal meanings for you.

our first consciousness of the image—possible readings have suggested themselves to us, and they have continued along the way.

Looking at an art object, we recognize, remember, are reminded of other images and events. These associations can lead to fruitful and reasonable hypotheses of the work's depth if the visual data we have observed supports them. If not, we must rethink our tentative interpretations. In the forest analogy, it is a bit like trying one path that soon disappears, going back to the clearing and trying another and yet another trail. Several may lead somewhere . . . even if that somewhere is the place where we began.

Art interpretation does not "explain" the work, for it cannot. There are no verbal equivalents for the visual expression in a work of art. If there were, humans would have no occasion to make art, for art's power lies in its ability to express what language cannot.

Nor, in interpreting, is it necessary or important to try to figure out what the artist thinks or believes. (Remember that artists are not always the last word—or even a very reliable word—on their own work's meaning.) As the artist's trail disappears we push on, examining the work in a new territory that is marked by our own desires and beliefs and experiences.

Feldman has pointed out, and I agree, that art criticism is no substitute for aesthetic experience.[3] But the informal and organic style of criticism this book has put forth can help us to a spiritual engagement with art. Interpretation is an important part of that process.

This chapter will very briefly look at ways in which interpreting art is similar to making art. We will use the elements of art criticism, which form a background for interpretation (what we have been examining in chapters 5 and 6), in a way that is comparable to the artist's use of the elements of art. The discussion will not ignore judgment altogether, because people irresistibly evaluate what they see, and finally it will come, full circle, back to response.

Elimination and Arrangement

Interpretation is in some ways parallel to the artist's work of creating images. Even though the skills and elements of art-making differ from the skills and tasks that form the basis for interpretation, the process is much the same.

Elimination

The most fundamental act of creating art may not be mark-making, as I seem to have implied in chapter 6 (how then would

one explain film, performance art, or conceptual art?). Rather it is first an act of *choice*, or its complement *elimination*—for to choose, in every instance, is to rule out. (If I choose to buy a small advertising picture from the 1930s in an antique shop, I rule out several hundred other objects for sale in that shop. If you decide to eat a bowl of Wheaties for breakfast, you have eliminated eggs, pancakes, bacon, donuts, and enchiladas.)

There are subtractive and additive methods in art; the act of elimination is most explicit in the subtractive method. Michelangelo once described sculpting in stone as simply eliminating the excess; to him the image was locked inside the block of stone. Collage, assemblage, steel, glass, plaster—much of modern sculpture—is additive, but also ancient works like pre-Columbian figures made of cut and shaped clay forms, hardened in a fire. But even in the additive process, more material is left out than included. I pick up a soft black pencil to draw a line on a sheet of rag paper, and thus eliminate an endless number of possible ways of making a mark and an equally endless number of surfaces on which to make it.

Arrangement

The second fundamental act of making visual art is sorting, or *arranging*. Every work of visual art involves the composition of visual elements on or in a given space. Arrangement is obvious in collage and assemblage. But even the simplest of art objects, such as Rothko's black paintings for the *Chapel,* are arrangements of edges into right angles, of four corners into rectangles, of varying shades of black or white across the surface and, for the viewer, the arrangement of the paintings themselves together with other visual elements in the space or on the printed page.

Interpretation As Elimination and Arrangement

This book has been written with the premise that there is no one correct interpretation to any work of art but layers of intended and unintended meanings supplied by the artist, history, society,

and viewer. As the basic acts of art are elimination and arrangement, why not arrive at various interpretations for artworks by means of elimination and arrangement? Visual evidence for interpretation is gathered as we describe and analyze.

Here the method of *questioning* applies particularly well. We can ask ourselves questions about the art object, which lead us by elimination to increasingly possible hypotheses.

Teachers frequently use the questioning technique to draw students into interpretation, but you can use it on yourself. Start with the most obviously improbable questions you can think of, questions that could only be answered with a "No." Keep on asking implausible questions—you will quite naturally lead yourself by stages to "Maybe," "Possibly," "I think so," "Yes, with qualifications," "Definitely," and "Eureka!"

Don't be afraid to ask ridiculously obvious questions; however, once asked, take the questions seriously. I once asked students viewing a sculpture by John Chamberlain, a block of crushed automobile body parts, whether they thought *craft* was an important element of the work. I expected a unanimous "No." But two people answered "Yes." What did they mean? They explained that the way in which the work was made supported its meanings. They saw not only visual elements of form and color, but also a narrative content. Eureka!

Free association, a variant of questioning, asks: what does this artwork bring to your mind? You are looking (or rather, waiting) not for opinions and reaction, but for memories, images, and ideas that it triggers in you.

Recently I grabbed a quick tour of a museum exhibition, intending to come back later when I had more time. I stopped in front of *Orange Break* by Susan Rothenberg. The large canvas is saturated with intense red and red-orange. A contorted, androgynous, abstract human figure, stretched into a circle until it breaks apart in the middle, is rendered with rapid, anxious brushstrokes. Powerful, I thought, but hard to look at, darkly erotic, emotionally and psychologically unsettling.

I stood in front of the painting for a few moments, letting my initial reactions fall away. I noticed that one negative shape resembled a serpent's head, and another negative shape looked like the tail of a bird or fish. Behind me someone remarked, "She's devouring herself!" By now I was free-associating. In my mind appeared an image—two snakes eating each others' tails, from the novel *In the Lake of the Woods* by Tim O'Brien (a similarly dark work).[4] A thought—on the desire to possess the object of love, to possess oneself. An observation—one figure, breaking apart and coming together at the same time. The painting began to open up for me. I might have passed it by, but having had time for reflection, I was eager to go back, have another look, see what it would yield.

A form of conceptual arrangement that may enable your fruitful interpretation of an artwork is to *compare and contrast*, a technique introduced in chapter 4. Find two or more artworks that share some obvious feature—subject matter, a visual metaphor, or a similar arrangement of objects in space. Begin asking questions: How are these art objects alike? Make a list of everything that catches your attention. Then list how they are different. You many wish to structure this experience by using a Venn diagram. Draw two overlapping circles, each one representing one of the two artworks you will compare and contrast. In the outside area of each circle, list attributes that are unique to each artwork. In the shield-shaped ellipse of the overlap, list their similarities. In those similarities and differences you will find clues to the works' content. (See Questions and Activities for Discussion for several suggestions of works in this book to compare and contrast.) Try this method yourself, standing in front of any artwork that troubles or confounds you. You may not grow to like the work, but if you offer it your openness and time, it will almost certainly yield something in return.

Having analyzed those aspects of a work's form that contribute to its spiritual content, you are ready to place the work in a cultural and historical setting, to investigate the artist's life and

times as a background for a better informed interpretation of the work. (You may know some of these things even before seeing the art object, or you may need to do some research.) Knowing, for example, that Käthe Kollwitz had a lifelong sympathy for the poor and suffering—that she and her physician husband treated many of their patients without charge and often took them into their own home, which became a kind of hospice for the indigent, that she took the side of workers and peasants who struggled to throw off oppression, that she even chose printmaking as her primary medium so that her works would be affordable—gives special dimension and meaning to her work.

Learning about the historical context is not to remove a living work of art from the present back to its dead past, but to see it as the expression of a real, flesh and blood human being caught (as we are) within the limits and cultural biases of our particular time and place.

Judgment

I stated at the outset that this book would not be concerned with ranking or setting standards in art. But we all *want* to judge. We cannot resist evaluating what we see and interpret. There is, after all, such a thing as quality in art—though explaining how to discern it is a bit like nailing Jell-O to a tree.

We compare one work to another from a different period in history, for example, and may find that they reflect vastly or subtly different values; the important thing to consider in forming judgment is not whether we agree with these values but rather how well or persuasively the works impart them. We might also ask whether the artist has expressed those values with authenticity and integrity—that is, with an image that is believable on some level and not trite, a form that is appropriate to the content, and a directness of vision that can only occur when the artists dance with their own dreams and materials and not with the ideas and styles of others.

EVALUATE

You do not have to pass judgment on an artwork. However, viewers who become practiced at description, analysis, and interpretation usually find that evaluation comes quite naturally and with some confidence.

Originality

Is the image trite, or overused, formulaic, or overly cute?

Does the artist offer insight, a fresh approach, a unique (quirky or profound) point of view?

Does the image have a certain presence of its own?

Craft

Does fine crafting support or detract from the immediacy and power of the image?

Is the artwork loose, free, painterly, textural, or just sloppy?

Design

Is the work well designed? (For example, does it have balance, unity, variety, rhythm?)

If the artwork is functional, does the form follow the function?

Is the work readable? Does it have a focal point? If it is confusing, does the confusion seem to support the content, or is it just bad design?

Expression

Is anything being expressed (remembering that it does not have to be "deep" or serious)?

How well do the physical elements—materials, media, shapes, colors, etc.—support the work's meaning or content?

Does the work evoke anything in me?

How do you recognize the difference between a fresh rein-
terpretation of past art, and *pastiche*, or empty imitation? The
answer is that one must learn to trust the process. Trite or over-
used imagery offers little when it is subjected to this or any other
critical method. As we practice our descriptive powers and
interpretive skills, gradually we learn to recognize *pastiche*, to be
wary of trite and picturesque images, to question and probe
facile displays of technical dexterity for some deeper purpose.

Interpretation and judgment, wherever they occur along the
trail left by the artist, involve recognizing and remembering;
questioning; hypothesizing; comparing and contrasting; testing.

Never, however, concluding.

This trail does not end with a right answer, or even two or
three right answers, and in fact it does not end. As long as the
artwork exists and we exist, there is the possibility of growth and
revision in our understanding of its disclosive Word.

Response

Well this is nothing new:
We responded at first sight.
We looked and looked and looked,
 described and interpreted,
 eliminated and arranged.
We looked again . . .

. . . all along forming a response which, like interpretation, is
an interlace: shifting, changing shape, intensifying, fading out,
reversing itself, forming and re-forming Spirit.

The most rewarding response is a creative one. You may be
moved to create your own art in antiphony to another. Or you
may organize an art exhibit. Write an essay, a poem, a song, a
story. Find ways to use the experience of art in counseling sessions.
Think about liturgy as art, and participate with that awareness.
Arrange simple objects like a collection of rocks or shells, with

sensitivity to their physical and spiritual affinities, on tabletops, shelves, windowsills, walls. Collect certain images that—unlike traditional collections—have no marketable value but instead repeat a shape or a texture or a visual metaphor (like Oldenburg's *Ray Gun Museum*, a miniature gallery containing an array of otherwise unrelated objects in the shape of a right angle, resembling a toy ray gun, or my collection of smooth round stones).

You may *do* something—some truly absurd and joyful act—like the farmer who plowed and planted his field in a reproduction of van Gogh's *Sunflowers*. Write or direct or act in a play. Teach a class that relates art to some aspect of spiritual life. Create a space in your home that, along with its other uses, can be a place for prayer, an altar or chapel-like arrangement that suits your inner life, as active and complex as a Mexican shrine or spare and white, washed with natural light. Meditate, with art as your aid, focusing upon any work that is evocative for you.

At times, your spiritual response to art can be a healing event. It was so for a man I will call Tom, who shared this story with me during a workshop on the subject of art and spirituality. He had taken a business trip to Boston, accompanied by his wife, Carol, who had been diagnosed with breast cancer two years before. She was now cancer-free, but the disease hung over them like a cloud.

By Saturday morning Tom's business was completed and they were free to explore the city together. At the Museum of Fine Arts, Carol moved quickly through the exhibits and headed for the museum shop. Tom lingered in a gallery containing a huge canvas by Paul Gauguin to which he felt drawn. The painting had a long title: *Where do we come from? What are we? Where are we going?*

Unaccountably weary, Tom sat down, emptied his mind and regarded the painting. He felt saturated and cooled by the artwork's intense blue-green—the only warm colors, he noticed, were the orangey hues of a few figures, life-warmth emanating from their bodies.

As Tom looked, images began appearing to his consciousness. The closed form of a very old woman squatting in the lower left-hand corner, holding her head in her hands. Waiting for death, he thought. Lounging beside her, a lovely and robust young woman. In the center of the panorama, a youth apparently reaching his hands toward heaven. At the right an infant at the beginning of its new life. Elsewhere in the painting, absorbed in the blue-green paradise, domestic animals and people of various ages going about their lives. Four women on the right side of the painting reminding him vaguely of the female figures in Picasso's *Les Demoiselles D'Avignon*, but more natural and innocent, not predatory. A deity standing in benediction over the scene.

Tom began to realize that he was not tired from meetings and sightseeing, but from months of worrying, listening to Carol's breathing in the middle of the night, fearing her death. Here in front of his eyes was a tableau of the entire sweep of human life. Every stage, even death, appeared utterly natural. "No one seemed worried," he said. "I'd been forgetting that we are part of nature. We can't control it. We get born, work and play, seek God, receive blessings, and die." He went on to relate the feeling of peace that came over him after sitting with this work of art for half an hour. It did not diminish the value of Carol's life, his need for her, his wish that she stay well. But he felt conviction (not just assent) that they came from God and belong to God, that whatever happens, they will remain in God's loving care. To him, that answered Gauguin's questions.

If Tom had first read Russell's commentary on the theme of the painting as "the ignorance of destiny, the general lack of focus and understanding, which leads human beings to go on living in an aimless day-to-day way while inscrutable forces, stronger than ourselves, look down on us,"[5] it perhaps would not have changed his experience. He also grasped the sense that we have no control over the natural laws and forces that rule our existence—but from the perspective of faith. Tom's understanding rose from

direct encounter with the artwork, from careful observation and his vulnerable openness to the Spirit's voice as he waited before it. For one half-hour the painting belonged to him. Other interpretations, even the artist's intended meanings, were less important than the work's spiritual meaning to Tom at that particular time and place, in that state of mind.

Tom's response to the art went beyond peaceful feelings. For many months Carol had been urging that they adopt a baby, but he had resisted because of the uncertainty about her future. Knowing that he might one day be left alone with a child to raise, but with a revived sense that Carol's life and his are in God's hands, he found himself ready to begin the adoption process. By now I imagine they would have their little daughter.

Responding to a work of art has no ending point. Once you have ventured down the forest trail it crosses and recrosses itself, divides and branches out. On a trip abroad, you may walk into a museum and encounter an artwork you first responded to only in reproduction—usually with a glad shock of recognition as your earlier reflections resurface and you begin again. Or, days or years later, your memory of a work may enrich your understanding of a sunrise, a poem, a play, a dizzying dance, a thunderstorm, a moment of silence, a time of grief or intense joy, your own impending death. Until that end, the art will keep on forming Spirit within you.

Part Three
Art As Confrontation
and Communion

Eight

Art As Prophetic Word

What are the roots that clutch, what branches grow
Out of this stony rubbish? Son of man,
You cannot say, or guess, for you know only
A heap of broken images, where the sun beats,
And the dead tree gives no shelter, the cricket no relief,
And the dry stone no sound of water.
 —T. S. Eliot[1]

One must go through life, be it red or blue, stark naked
and accompanied by the music of a subtle fisherman,
prepared at all times for a celebration.
 —Francis Picabia[2]

Art is a visual word: it proffers an antidote to numbness and broken images by embodying and reenacting the mystery.

Art is a prophetic Word: it proffers an antidote to the dead tree and the dry stone by forming, and calling us to form, an alternative to those prevailing beliefs and values of a culture that threaten spirit—that trivialize experience, anesthetize feeling,

and estrange people from others and from their own selves.

Art is an absurd word: it prepares us for a celebration.

We have examined art as visible Word, as sacramental (though by no means a sacrament). The present chapter explores the wider extent of its potential for embodying some other reality beneath or beyond its surface. The visible Word is companion to the verbal, the prophetic, and the pastoral Word; here we will explore ways in which visual art can be a *prophetic Word* raising its image-voice against injustice and greed, facing death squarely, and enabling us to imagine and form an alternative to the ruling order within ourselves and in our world.[3]

The Ruling Order

Have you ever felt that some unidentifiable "they" are responsible for (pick whatever applies): unemployment, materialism, alienation, poverty, greed, homelessness, addiction, the high cost of medical care, war, crime, racism, sexism, classism, failing banks, carcinogens, rising taxes, potholes, overpopulation, oppression, the decline of the family?

They are robbing us blind. They are out to get us. They don't care about the little people. They can't be trusted. They profit from our problems. They are after our jobs. They manipulate us. They say . . .

Who are *they*, anyway?

The assumption is that, somewhere out there, a group of people manipulates the rest of us for their own ends, to preserve their power and wealth and keep the rest of the population numb, alienated, docile. Some people think that *they* are politicians, others blame the military-industrial complex, still others point a finger at white males or a certain ethnic group (Aryans, Jews, Arabs) as the source of society's ills.

It is clear that people who use *they* in the above sense are not talking about individuals but about an order—though occasionally a person (such as Adolf Hitler, to cite the extreme) may

become a symbol of that order. It might be named the ruling order, the prevailing culture, dominant consciousness, Mammon, or countless other variations of what Walter Brueggemann calls the Royal Consciousness, the Imperial Reality, and the King.[4] It is the power that controls, that enshrines ontical reality—"thingness"—and turns its face from the Spirit, from human suffering and death, and even from joy.

But the ruling order is not only a *they*. It is a *we*. It is not only the president or members of congress. Not just generals, manufacturers of helicopters and missiles, police, advertising agencies, foreign despots, multinational corporations, the media. Some of those may indeed be pushers and dealers of mindlessness and spirit-numbing consciousness, but the writer and the readers of this book most likely have an investment in the prevailing order as well. We are the users, we reap at least some of its benefits—and, as in the drug culture, *the users are the perpetrators*.

Whoever subscribes to the ruling order's values—haves and have-nots alike—share responsibility for it. A few years ago in my city a twelve-year-old boy was arrested for operating a drug-selling operation. I had my radio on when a reporter interviewed the boy. "Why did you do it? To get drugs?" the reporter asked.

"I don't use drugs, I did it because I wanted to buy a motorcycle," was the boy's reply.

"Did you think it was right?"

"No, it was wrong."

"You knew it was wrong?"

"Yeah."

"Then why did you do it anyway?"

The child's exasperation hissed through the airwaves: "I *told* you why I did it. I wanted to buy a *motorcycle!*"[5]

The users indeed are the perpetrators, and many of us are more committed to the ruling order than we realize. We want to buy a motorcycle, and we work the system accordingly. This does not call for spurious guilt feelings, just recognition of our part in the scheme. And, perhaps, compassion toward others who transgress.

Once when I was a young girl, contemplating wars and racial violence, I said to my father: "If only everyone in the world was like us, things would be better." "Ah," he sighed, "but that's just the problem—everyone in the world *is* just like us."

Art and the Prophetic Task

Make the heart of this people fat,
>and their ears heavy,
>and shut their eyes;
lest they see with their eyes,
>and hear with their ears,
and understand with their hearts,
>and turn and be healed. (Isaiah 6:10)

Not all art serves as prophetic Word. Art is not the sole or even the primary prophetic ministry. Nor is it the only available way to reenact an alternative consciousness (see chapter 9). But art is a seminal forming activity, and along with its other functions can have a prophetic voice.

Like religion, art also can be made into a thing, in service of the ruling order. When art is objectified, dealers and auctioneers, speculators, collectors, art critics, museum curators, art magazines, newspapers, the auctioneers' caterers and parking lot attendants, and occasionally even the artists, profit by it. Separated from its powers to confront, challenge, enact, enable, even to give joy, art becomes an ornament, a commodity, a conversation piece. It is controlled.

But in the end art seems to *resist temporal control*, for it exists in the future as well as in the past and the present. For one thing, barring catastrophe, the Rembrandt painting that was around three hundred years before we were born will endure in times long after ours, and will have new meaning for those times.

What is more, the act of making art often is a *step into the future*. In the Renaissance, artists were on the vanguard of a new

way of thinking that discarded pure reason as "learned igno-
rance" and made experiment, observation, and experience a
rightful avenue to knowledge. The artists' careful observation of
nature laid the foundation for the scientific method.

At the beginning of the twentieth century, for another exam-
ple, artists once again were on to something new. Color was freed
of its literal associations; representation became optional; new
sources for images (such as dreams) were explored; matter became
permeable. "Space no longer exists," claimed the Italian futurist
Umberto Boccioni and his friends. "Our bodies penetrate the sofas
on which we sit, and those sofas penetrate our bodies. The motor-
bus rushes into the houses which it passes, and the houses in turn
throw themselves on the motorbus and mingle with it."[6]

Artistic revolution was in the air; surely these artists were
cutting themselves off from their public. But, Toynbee writes,
"So far from that, they were giving artistic expression to feelings,
thoughts, and desires that they shared with their public. They
were not deviating from the course on which their public's feet
were set; they were actually anticipating this course."[7]

Art often can be found on the advancing edge of its sur-
rounding culture: exploring, testing the waters, questioning the
status quo. Art that stubbornly refuses to be today what it was
yesterday brings into question the permanence of the present
order. And the illusion of permanence is what the ruling estab-
lishment must perpetuate, for fealty to a temporary power is hard
to enforce.

Art's Prophetic Voice

As a kind of early messenger for new directions in society, art has
a prophetic consciousness that is difficult to control. It can stand
over and against the ruling order in judgment: not against indi-
viduals or even specific issues, but against rootlessness, self-
absorption, stagnation and ease, oppression and institutionalized
cruelty, despair—or, in Brueggemann's words, "domestication of

vision." We have seen this well in the works of Hopper, Picasso, van Gogh, Beckman, and more.

Mute Messages

One reason visual art is an impressive prophetic medium is that it seldom does a good job of rebuking or haranguing over specific social issues, which easily remain on the surface and can be dismissed just as easily. People and institutions, sensing attack, tend to build their defenses higher. But art confronts with silent images against which there is no defense.

Consider the works of Magdalena Abakanowicz, who as a child in Poland lived through the horrors of World War II and great hardship in the years that followed. She has given us *Backs*, eighty compelling figures whose positions vary according to the site where they are installed but always sit in rows, closed, mute, facing away. Without voices, heads, or even bodies, they speak. They have the capacity to bring us into communion with suffering and enduring humanity.

Such images owe their impact in part to the natural credibility of the visual. Advertisers, for instance, accompany their words with pictures of youth, sex appeal, and belonging that have nothing whatsoever to do with their product. The pictures work: we believe our eyes. Photographs are especially deceptive precisely because, even though they are the result of enormous selectivity and can be cropped, reversed, retouched, and electronically manipulated, we trust them.

Seeing, we suppose, is believing.

Laughing in the Face of the King

Yet another reason for art's potential as prophetic Word is that art does not have to be very serious to accomplish the task. There always has been an element of humor in art; even monks laboring over manuscripts in the middle ages occasionally included their own private jokes on the illuminated pages—sometimes scathing, pointed satire, sometimes merely comic.

The use of humor as a weapon can be seen in the dada movement, begun as a desperate iconoclastic assault on the violence and insanity of World War I through an equally lunatic art (or anti-art). Here is humor that cuts to the core. We laugh at absurd creations by dada artists—works like Man Ray's "useless functional objects" such as an iron with sharp spikes protruding from the bottom plate, or Meret Oppenheim's *Object* (a real teacup, saucer, and spoon, lined with fur). Nancy Graves's *Wheelabout* is joyously absurd and equally useless as a means of transportation. But this is a laughter edged with panic because the object threatens reason. What if the logical order of things should collapse?[8] The hated one is made to look ridiculous and thus assailable.

Sometimes the artist plays the clown, the absurd prophet crying, "vanity of vanities! All is vanity." (Ecclesiastes 1:2) Perhaps it is no accident that the humorous and irreverent, the *goofiest* art, often threatens and angers people the most. In the face of dominant reality—of destruction and waste, injustice, bigotry, hunger, suffering—joy is absurd. The clown laughs in the face of the king.

Art Mobilizes and Sensitizes

The image of a clown before the king is a scene of action and emotion, two important arenas for art's role as prophetic Word.

Art Mobilizes

Prophets seek to goad people out of their lethargy and numbness, to make the alternative a possibility, at least for a time, at least for their own private lives. For all its brawn, the ruling order ironically is a rule of *inertia*. Who has not complained of the slow pace of change in a great bureaucracy? At times it feels as if we can do little to affect the way things are. George Segal's white plaster figures express well this feeling of hopeless ineffectuality. Sitting motionless in their ordinary and graceless poses, they appear not so much frozen in the midst of an act or silent in contemplation

as, simply, inactive. There is nothing they can do. (Again we see similarities to the people in Beckmann's *Family Picture*.) Francisco Goya's men encased in white bags (*The Men in Sacks*) are prevented from acting, bound, trapped. Such inertia is necessary for the continuation of the dominant culture. *The inactive ones are the perpetrators.*

Art not only sheds light on this fatal stupor; it counteracts it. It is physical, the result of an act calling forth a corresponding act of response. It does not merely explain but *forms* experience, and this forming has a tendency to generalize into other areas of life. Inevitably, when people engage in interpreting artworks, they recognize themselves and their situations, they reflect, they apply what they observe in some way, however small.

Art Sensitizes

This may be art's most viable prophetic role. It does not avoid emotion. Passion is at the center of the act of art-making and cannot be suppressed; even Byzantine icons, made in workshops according to established formulas, reveal the makers' intensity of feeling.

Visual art also has the power to evoke strong feelings in the viewer. I cannot think of one instance, walking through an art gallery, when I did not hear highly emotional responses to the art. Sometimes that response is sorrow, or peacefulness, or laughter, anger, delight. When asked to write their responses, it is not unusual for people to express deep and secret feelings on paper after spending time with a particular work of art.

To be sure, not all artists have confronted the suffering of others with empathy or passion. Some have obliged the oppressor, dignified war, made poverty picturesque. For example, wealthy merchants and landowners of the sixteenth and seventeenth centuries enjoyed paintings that portrayed a rather oafish peasant class—happy, fun-loving, drunkenly mindless of their poverty—like the paintings of Pieter Brueghel the Elder. People still apparently enjoy such works, as they are commonly

reproduced on greeting cards, puzzles, and coffee mugs. (But even here is an instance of art's unruliness. The works of Brueghel, picturesque and soothing as they may have been to an exploitative landlord's conscience, can be read on a number of other levels: as social satire that is hard to miss once you look for it; as illustrations of popular proverbs; or as a biting comment on the human condition. Brueghel was, in fact, rather shrewd at getting across his criticism of the ruling order in subtle ways that left him free of reproach and therefore of disfavor, imprisonment, or death; his more obviously political drawings were made public only posthumously.)

There are other exceptions. In the nineteenth century a few artists chose *escape* as a way to deal with the enormity of war, poverty, disease, and human suffering that faced them. Some of these Romantics glamorized America's dramatic geography; popular ideas of the time, especially Manifest Destiny (the notion that God had foreordained westward expansion by European Americans), found expression in big landscape paintings that were both glorious and didactic in their inherent nationalism.

Other nineteenth century artists such as Goya and Daumier were prophets who identified with the common people and fearlessly made visual their plight. Their vision prefaced expressive works of the late nineteenth and early twentieth centuries, which exemplify the mobilizing and sensitizing function of art by stirring people up, opening them to feelings that might otherwise be buried, concealed, avoided.

Many of the artist-prophets of our own time have chosen to evoke the pain of a troubled century. Michael Tracy's identification with the suffering of his brothers and sisters in central America led him to create his unsettling *Chapel*. The German painter Anselm Kiefer seems dedicated to pricking the public memory of the Holocaust—to the need for addressing the "tension between the immense things that happened and the immense forgetfulness."[9] In his early painting *Quaternity*, a huge work in oil and charcoal on burlap, the threat of evil invades a

wood-planked upper room where three fires—labeled Father, Son, and Holy Ghost—burn on the attic floor. Evil in the form of a serpent labeled *Satan* enters the ring of fires.

Consuming fire, or holocaust, is the principal symbol for the murder of six million innocent people in our time; it is also a symbol of purification. What is the import of fire in this work? Will the serpent be consumed? Will the house be consumed along with the serpent? What questions does this painting raise about the existence of evil in the human mind and heart?

Art and Death

> Our days are like the grass;
>> we flourish like a flower of the field;
> when the wind goes over it, it is gone,
>> and its place shall know it no more.
> (Psalm 103:15, 16)

Among the many feelings people tend to avoid or bury are those that concern death. I once sat in a cafe and listened while three youths in the next booth discussed the suicide of an acquaintance a day or two before. They seemed painfully uncomfortable about the subject and talked in loud and excited tones, laughing nervously even though they evidently had known the boy well and were deeply affected by his death. Nothing in their lives— certainly not the thousands of virtual deaths they had witnessed on television—had prepared them for this.

Keeping Death at Bay

Perhaps all people are a bit like those boys. All have some fear of dying, yet death fascinates. Why do we die? What happens afterward? Death's mystery is permanently enigmatic. It is perhaps the most persistent reality of human life, yet we have no way of assembling empirical evidence that will let us know objectively what awaits us. So death remains a paradox—unknowable but

certain. Medical science makes progress toward delaying it, but in the end death will face us all. We know this in our heads; the problem for most of us is knowing it, as a friend of mine recently put it, "in our *knower*"—that is, in the center of our being.

People and societies can keep death at bay in a number of ways. One is to refuse to talk about it, find euphemisms for it: we speak of one who has passed on, expired, gone away. Another way is to hide death from view. In first-world countries, people seldom die at home anymore; they are out of sight in hospitals and nursing homes. Or in the streets. It is ironic that urban, Western society has hidden death while simultaneously creating a cult around it. But it is a cult of cinema death, television death, front page death, death by special effects. A certain desensitization is likely to take place when so many fatalities per day are viewed on the screen.

Art's Most-Recurring Theme

As a sensitizing force, art has an ability to bore through to our center; certainly its treatment of death is a prime example of art's prophetic role. Even when societies have denied death, ignored it, pushed it under the rug, artists have relentlessly addressed its steady presence. From the beginning of our race people who make images have dealt in one way or another with death—as in Egyptian art, in large part an attempt to ensure some kind of continuing existence in the afterlife; or the death masks from Mycenae and Crete and the embellished skulls of Jericho; or early Christian paintings in the Catacombs. Death is one of the most enduring themes in art.

Facing Death's Mystery

One thing faith and art have in common is that they express our feelings about death. Art has stubbornly resisted attempts by society to prettify or hide or dramatize death. Paintings such as Ryder's *Death on a Pale Horse* are part of an unbroken line— from ancient times—of artworks that take death as their subject.

Such works may not be easy to like—certainly not the grotesque paintings of Francis Bacon, whose words on the subject of death give insight into his works:

> Death is the only absolute that we know in this life. . . . Most artists are very aware of their annihilation—it follows them around like their shadow, and I think that's one of the reasons most artists are so conscious of the vulnerability and the nothingness of life.[10]

The artist who shows us the face of death may be a prophet crying "All flesh is grass." To those who are open to it, the experience of art can help an individual or a people to acknowledge death's reality and come to terms with its mystery. That process, however difficult, is at the very heart of our private and collective spiritual journey.

The Prophetic Promise

Objects can be mastered, but there is no controlling grief, pain, mystery, death, imagination, joy. Nor are these experiences easily expressed in words. In fact, as prophecy, words often go unheeded while images carry the message home. In his sermons, Martin Luther King painted scenes that captured the imagination of his followers. Perhaps nothing impedes positive social change more surely than a people's inability to *imagine*. The prophets of the Hebrews were a mere technicality removed from being visual artists, so vivid were their word-images.

Art also has the potential to be a disclosive, embodying, enacting Word that can form an alternative within us and within our community. It is an antidote to those elements of the ruling order that poison by isolation and numbness. For art, on the whole, is experienced privately: we meet the mystery alone, yet paradoxically the event releases us from alienation and makes real community possible.

We acknowledge the mystery, and paradoxically God becomes more real to us than a folksy, friendly, immanent God could be.

We encounter death, fear, pain, grief. And thus, paradoxically, the abyss can be crossed. Accompanied by the music of a subtle fisherman, we prepare for a celebration.

Nine

Art
Forming
Community

It is more than a hope . . . that the artists among us will help us all to measure our strengths rather than our fears and weaknesses, will help us to discover and define what we, as citizens of the whole world, have in common, rather than in contention.
—Charles Champlin[1]

Most vital human mutuality therefore occurs by products of human art, by objects crafted by us to make a shared world. . . .
—Robert Jenson[2]

The nineteenth-century American painter Albert Pinkham Ryder was an archetype of the artist as a romantic genius, engaging in a kind of private dance with ideas and materials, shut away from the world in a garret, surrounded by the clutter of paint tubes and discarded sketches, intense and eccentric. Ryder lived alone in an apartment piled to the ceiling with his accumulated debris. He had no concern for possessions or even basic comforts—ate gruel from

a pot kept on a single burner to which he added whatever food happened to be at hand, dressed in rags, discouraged visitors. It is said that, on occasions when he ventured to the street, strangers would approach and try to give him money (an earlier, gentler New York). A few loyal friends looked after him, saw that he ate, tried unsuccessfully to move him to a clean apartment. Ryder's paintings were idiosyncratic and symbolic, infused with personal and spiritual meaning (see *Death on a Pale Horse*.) On the occasion of a breakthrough in his work he wrote these lines reflecting his singularity of passion:

> The old scene presented itself one day before my eyes framed in an opening between two trees. It stood out like a painted canvas—the deep blue of a midday sky—a solitary tree, brilliant with the green of early summer, a foundation of brown earth and gnarled roots. There was no detail to vex the eye. Three solid masses of form and color—sky, foliage and earth—the whole bathed in an atmosphere of golden luminosity. I threw my brushes aside; they were too small for the work in hand. I squeezed out big chunks of pure, moist color and taking my palette knife I laid on blue, green, white and brown in great sweeping strokes. As I worked I saw nature springing into life upon my canvas. It was better than nature, for it was vibrating with the thrill of a new creation. Exultantly I painted until the sun sank below the horizon, then I raced around the fields like a colt let loose, and literally bellowed for joy.[3]

Ryder's paintings influenced twentieth century abstraction with their purity of feeling and spiritual intensity. His was a singular vision, yet it communicates to many. In isolation from "normal" society Ryder was able to capture a sense of our complex and sometimes difficult relationship with nature. Correspondingly, the contemplation of Ryder's works may well draw the individual viewer deeper into an understanding of one's own private dance with the forces of the universe.

The Private and Public Nature of Art

But art is more than a solo performance. Among the many tensions that exist in the creation and experience of art is its private versus public nature. Because this book has focused on popular (as opposed to academic or journalistic) art criticism, it quite naturally has emphasized the personal and individual nature of contemplating and interpreting works of art. Even prophetic art is most effective at undermining the dominant culture when it summons the private grief of the oppressed, evoking in the viewer a rush of tears or a tightened throat, a response of empathy, a recognition of one's own emptiness or a moment of reckless joy. Indeed, art's great strength as a conveyor of meaning is that it is a record not only of public events but also of personal experiences acted out and apprehended in private.

The romantic notion of the lonely and idiosyncratic artist, of which Ryder was the quintessence, is a relatively modern Western myth. Medieval artists toiled together in ateliers producing images in a common style. The apprentice or guild system in which aspiring artists assisted in the studios of older, accomplished painters or sculptors was the principal way for artists to learn their craft until academies and universities took on that role. In the twentieth century artists have found new ways of collaborating—such as film, environments, and performance art—that require the participation of others.

The present chapter addresses art's unifying role—in a sense, art as *pastoral Word*. It will include specific suggestions for ways in which art can enrich the shared life and worship of a community of believers.

Images Form Community

Images not only form our personal spiritual experience; they also in large part *form a community's identity*. Even artworks that reveal the inner life of an individual also express the worldview of a group—a club, a school, a business, a city, a political party, a

nation, a church, a culture or subculture. The previous chapter noted that nineteenth century painters of America's dramatic landscapes linked its national identity to its geography, both literally and symbolically, even mystically. God was embodied in those grandiose aspects of nature, and by implication God's blessing fell upon the European newcomers' domination of the continent.

Furthermore, some art specifically *addresses communal themes*. Works such as Magdalena Abakanowicz's *Backs* and Goya's *The Men in Sacks* hold our sameness—our membership in the great body of humankind—in tension with our individuality.

All art is expressive of its time and its culture, even if that expression takes the form of rebellion. But art also *stands aside from its particular culture*. This is evident today, but even in the most controlled of medieval workshops, the artist's passion often made itself felt in the artwork. Such were moments of disclosure; the art was lifted from the particularity of its cultural setting to an expression of humanity or Spirit that is common to all.

There seems to be no way to separate the private from the communal experience of art, for the most intensely personal art—and often, therefore, the least tied to ideologies, value systems, or customs—is also the most inclusive. What binds us together may not be so much the group characteristics of a culture as the private experiences of individuals who repeat their parent's sins, eat and drink, protect and nourish their children, grieve, rebel, fear death, long for something more. Tire. Grow old. Defend, protect, surrender, flee. Who live their lives in rhythmic cycles and mark them with rituals.

The artist may work in solitude, like Ryder, or in collaboration; the viewer may contemplate the work in seclusion or among other people. Whatever the case, inevitably the art event will have some kind of impact on the community.

Art's impact on the community may be indirect, as when our personal responses to the art affect our relationships with others. In the case of my response to Hopper's *House by the Railroad Tracks* (see chapter 5), should I even once reach out to another

person as a result of observing how I make myself like that iso-lated and empty house, that active response becomes an occasion of community.

Art also may be experienced in community directly. Just as artists throughout history have worked together, so have viewers participated with others in their experience of art.

Liturgy, for example, is a shared act of faith and art. From ancient times to the present, people have made images an integral part of their rituals and beliefs. The performing arts are by and large communal in nature, involving the efforts of writers, com-posers, choreographers, directors, musicians, actors, dancers, cos-tume and scene designers, audience, and many more.

Contemporary society also provides for some mutual experi-ence of art. *Art museums and galleries* extend such opportunities. They permit individual experiences of art; but they also offer occasions for collective observations, interpretations and responses through group tours, lectures, concerts, symposiums, dialogues with artists, Saturday art classes, and the like. It is hard to go to the art museum on a weekend and not rub elbows with scores of people in designer fashions or frayed blue jeans, looking at the same works of art, overhearing their comments, even strik-ing up a conversation about some aspect of a work that has caught your eye.

In public and private *education*, visual art is a corporate expe-rience. Most studio art is taught in groups, and the shared energy of the class often enriches the individual's experience. Ideas are discussed, techniques are passed on to others, problem solving is a shared activity. Except for professional artists, the majority of peo-ple as children and adults have made art primarily with others.

Likewise, *art history* and *art appreciation* are imparted in groups, though teaching styles may affect the degree of commu-nal experience. My first college art history class was conducted lecture style in a nearly filled five hundred seat auditorium, with no opportunity for questions or discussion. How remarkably dif-ferent from a later art history seminar I attended on Cezanne and

van Gogh, when students and teacher mutually explored the works of these two painters through reading, writing, and creating our own artworks.

Cinema—perhaps the definitive modern collaborative art— is most often viewed in groups, and it is usual for people to discuss their interpretations and reactions to films with others. "What movies have you seen recently?" may be an opening to some very personal revelations as people respond to a film that has moved them.

Controversial art also brings people into community, as they attack, defend, strive to understand what they have seen. A candidate for the most controversial painting of the twentieth century, Duchamp's *Nude Descending a Staircase*, portrays not so much the nude model as the *act of descent*. When it was exhibited in New York in the blockbuster Armory Show of 1913, the painting became known across the country. People talked about it in the streets and wrote letters to editors; art critics excoriated it; even the President issued a statement of opinion about it. Art in America was never to be the same.

How could one painting, not so unusual among the cubist and futurist works of the day, exert such sway? Because people had strong feelings about it. It showed them a new world, and it was the world they were living in, and it didn't look very comfortable. The dispute provided a communal experience and a communal conversation about art, about change, about what is real.

Visual art as disclosive Word may enter the communal spiritual life at many points, and in at least three areas. First is the direct use of art itself in various aspects of congregational life. Second is the experience of liturgy as art, and third, a generalized infusion of these hermeneutic principles for visual art into the whole fabric of the life of faith.

Uses of Art

There are countless ways individuals, groups, and congregations can help others to experience the forming capacity of art. (It bears repeating that I write about visual art because that is what I know best; other fine arts should not be excluded and will provide a broader range of forming experiences that reenact the primal metaphors of faith.)

I am hesitant to begin a recital of helpful hints on how to use art in the public or private life of faith. This hesitancy is based not only on a desire for brevity, and on my reluctance to conceive of art as a tool, but also on the conviction that the readers have creative energies of their own, that their own engagement with and response to visual art will elicit that creativity. However, in a very general way I will suggest a few areas in which visual art might be given a central role in the God-person-person relationship, with examples of ways some congregations have discovered to make the experience of art an active part of their shared journey of faith.

Community Resources

Relatively few European or North American worshiping communities are far from art museums, universities, or art schools, where an ongoing variety of exhibitions and educational programs are valuable resources for groups of people who seek to nurture their spiritual experience through art.

Worksheets may be useful to guide responses. But in order to take advantage of the benefits of the group, cooperative interaction among members as they describe or answer questions is helpful and may lead to interactive responses. In other words, suggest that they discuss their questions and discoveries with each other.

It is important to avoid using group museum visits as theological scavenger hunts for works of art that seem to "say" something about specific religious tenets or moral principles. To do so might be interesting, but it would remove art from its forming role and turn it into just another reductive tool for study. (See the Questions and Activities for Discussion at the end of this book.)

Art in Church

Since the Reformation, the church has all but disappeared as a significant patron of visual art. Part of the reason for this waning interest in art is ideological; some Protestant groups initially forbade images and a few still view art with mistrust (see chapter 2). But much of the cause is economic. No church has the concentration of power and wealth enjoyed by the popes of the sixteenth century. (Even then, wealthy bankers and merchants of cities such as Florence had become hugely influential in the direction of visual art.) Today, many churches struggle to meet their basic needs financially.

I have been struck, however, by the discordance of a church spending hundreds of thousands of dollars on a pipe organ that (I will grant) enhances its worship immeasurably—yet hanging a "greeting-card-art" banner behind the altar, or installing stained glass that befits an arts and crafts fair or a cozy restaurant. Are these the sour grapes of a visual artist? Perhaps. But churches often neglect the aesthetic components of the life of faith, perhaps mistrusting the sensual or wary of the power of images; even churches that summon the aesthetic dimension through music and liturgy often seem unwilling to embrace the visual. What is no better (perhaps worse), many churches display pious images that are overly sentimental, trite, and shallow. Pretty to look at, easy to read, they are unlikely to draw us beyond the surface or challenge our cherished idols.

Surprisingly, there are a number of ways in which even financially-strapped congregations can include art of quality and meaning into their spiritual life.

Changing exhibitions (a rotation of temporary shows by various artists or groups) can be held in appropriate spaces, such as the sanctuary, classrooms, lounges, and parish hall. Planners can draw upon community resources, such as universities and colleges in the area.

Such exhibitions may be organized by *theme*, such as death and rebirth, isolation, poetry and art, obsessive art, or light.

Another way to structure group exhibits is according to *subject matter*, such as architecture; the cross or cruciform motif; hands; windows; shrines and altars; self-portraits; the human figure; decorative pattern. Other concepts for group exhibits include *medium* or *material* (such as works on paper, black and white photographs, assemblage, fibers, clay); *style* (such as new expressionism, abstraction, super-realism, primitivism; *format* (such as environments and installations); or *group affiliation* (such as a college painting class). You may wish to ask a guest curator to put together an invitational exhibit, or ask art instructors, museum staff members, art critics, or even graduate students of art to judge competitive exhibitions.

A program of changing exhibitions can enrich the congregation's spiritual life with an ongoing variety of visual expressions, and also can serve as a forum for artists who seek a broader venue for their work. If the church provides desirable physical arrangements (such as plain white walls and adequate security), as well as consistent quality, it has a good chance of becoming known and even sought after as a viable art venue.

Competitions may be held for permanent or semi-permanent artworks. I have never understood why more churches do not take advantage of this method for selecting permanent art installations. Artists are eager to submit their work for consideration in such competitions. Congregations that limit their choice to the architect's selection, or a member of the congregation, or a cousin of a member of the congregation, are missing the chance to see a rich variety of possibilities.

Classes and Group Experiences

Sunday or weekday classes for interested church members on topics related to the spiritual content of art will foster both individual and group interaction with art. Topics could include a spiritual interpretation of art, using this book as a guide, or reading and discussion of a variety of books in the fields of aesthetics, religion and the arts, art history and appreciation, and the like.

A college or high school art instructor in your community might teach a studio art class for church members that develops one's powers of seeing and perhaps even a meditative level of observation, using a guide such as Betty Edwards's *Drawing from the Right Side of the Brain*.[4] Discussions of the relationship between seeing and inspiration, and between inspiration and creation, as well as other topics suggested by this book, will enhance the experience spiritually. Studio art experiences might even be included in a course on spirituality or spiritual formation.

Another version of the studio experience might be to engage an artist in residence (selected with help, again, from a nearby college art department or museum) to work along with a group producing a mural, weaving, assemblage, sculpture, even a film or video, for temporary or semi-permanent installation. Such a project could be as simple and fleeting as sidewalk chalk drawings or sand sculptures or as complex and lasting as a fresco or mosaic. (Needless to say, the selection of the artist becomes increasingly critical as the project becomes more permanent.) Certainly it can be an enriching event for those who take part.

Art festivals. The most enlightening and joyous art festivals I have experienced were participative events, including demonstrations and workshops such as clay throwing, sidewalk drawing with washable pastels, sand casting, a group assemblage, live musicians, and of course plenty of good food. Tying such events to some metaphor or theme of faith—like fire or light, death and rebirth, purification, the Reformation, community, enlightenment, even "absurd joy"—can help make them meaningful experiences for all.[5]

Images of Worship
Art serves worship.

That statement may seem at first to relegate art to the realm of functional objects, like the chalice, altar cloth, pews, or appliances. But in fact the elevation of carved, assembled, stitched, welded,

and painted images to a level quite removed from daily life is a recent and artificial phenomenon. And anyway, the *experience* of worship is quite unlike the act of vacuuming the carpet, and is even quite unlike *acts* of worship, taken individually, which require various props.

The experience of worship is somewhat akin to the experience of a work of art: when you give enough time and reflection to an artwork, it becomes a part of you. You bring to it your questions, emotions, non-verbal memories; the artwork answers and affirms and reminds. It has its own reality, and at the same time it participates in yours.

As an aid to worship, art acts in the same way. The handcrafted silver chalice moves beyond *prop* to *instrument* as it is offered to you by another, as it is lifted to your lips, as your fingertips touch its cool base, as its irregular surfaces flash reflected light, catch and multiply a color. As seen and touched by you, it becomes part of what it holds. In the corporate religious life there are certain images that, like the chalice, can bind us to each other even as they enrich our private faith. Wittingly or unwittingly, emphatic messages are passed through worship's images. These can forcefully convey the faith of those gathered . . . or they can garble the communication, give out mixed and contradictory signals.

Reflect on memorable worship experiences from your past. What stands out? I can remember sermons from twenty-five years ago that addressed my own struggles, or stimulated thoughts about faith and meaning, or told a meaningful story simply and well. Some words remain with us, to be sure. But on the whole it is the sights and sounds and smells that last over time.

Images: The warm sense of community in our summertime country church where the peace is passed around so enthusiastically that the pastor has to put and end to it before the service can continue.

Images: The culmination of a Good Friday communion, the empty chalice knocked over on the altar, worshipers leaving the church silently and without ceremony, many in tears.

Images: Liturgical dance, performed by students at an Anglican seminary, their white-clad bodies miming a psalm of praise with economy of motion.

Images: A gospel revival under cover of a canvas tarpaulin in the hill country of Texas, clapping hands and rhythmic music rising in the warm, humid night air.

Images: Advent devotions in my parents' home, one of us lighting candles on the handmade wreath as the family sang "O, how shall I receive thee, how greet thee, Lord, aright?"

Images: Kneeling silently in a whitewashed chapel, no thought, no words, no music, just diffused sunlight on the walls, an icon and a single burning candle, the sound of my breathing, the presence of God.

Images: Ash Wednesday, the antiphonal reading of Psalm 51, its rich visual language indicting and comforting a troubled spirit, " . . . let the bones which thou hast broken rejoice." The imposition of ashes on each forehead, the soft superimposed sounds of several voices murmuring again and again, in hypnotic cadence, "Remember that you are dust, and to dust you shall return."

Images: A Galilean service one summer evening at a Minnesota lakeside Bible camp, we on the shore slapping mosquitoes, two pastors and a crude wooden cross leading the worship from boats reflected on the still lake.

Images: Listening and watching as mass is celebrated in a tiny church built atop the first known place of Christian worship in Rome—two American Protestants following the liturgy without needing to understand the words, feeling connected with twenty centuries of Christians who gathered on this site, some in secret and danger of death.

Images: An urban harvest festival, people coming forward to pile their gifts of food for the hungry on the chancel steps. Sacks of flour, perforated plastic bags of apples and oranges and potatoes. Miniature cardboard cities of cereal boxes. Little bean bags of split peas, lentils, rice. Canned goods. Rolled oats. Baby food. On the altar, a bouquet of grains laid casually across the table. A

prevailing thankful feeling we all shared, struck and a little embarrassed by our plenty.

Images: Quietly singing hymns at the bedside of my dying mother—her eyes and her good hand raising upward whenever we sang a hymn of praise ("She's already on her journey," I whispered to my father; "She's seeing something we can't see.").

Images: A national park worship service, the young seminarian's pulpit set against granite peaks, spruce and pine our cathedral walls. Smell of dry needles for incense, wind in the pines for an organ, awakening in us a sense of the holiness of creation.

Images: A graveside service for a friend I loved on a hot cloudless Arizona day, hint of a breeze under the canopy shade. The twenty-third Psalm, restrained emotion in a glance, a touch, a faraway look. Good people in their best clothes, their shapes and colors distorted as through old window glass by my tears.

It is in such images of worship that we move from our private and personal relationship with God to our communal one. Churches that provide a paucity of images, that trust only the verbal word as a conveyor of meaning, are overlooking not the frills or even the thrills, but the energizing *center* of religious experience and the essential spirit-forming experience of image in corporate worship. They are limiting the possibilities for people to be encountered by the Word—both verbal and visible.

Worship and liturgy can be, in its fullest sense, *art*—a forming and disclosive Word.

Art in the Life of the Faithful

In our life together, art can be a force for confrontation, reconciliation, invigoration, and healing. Readers will discover for themselves ways in which art can enhance their ministry to others in any number of areas. Such areas might include: preaching in images that communicate more powerfully than literal exposition can ever do; encouraging openness and receptivity; spiritual guidance and direction; renewed methods of prophetic practice

that foster a sense of solidarity with the oppressed; and perhaps above all else, a life of faith lived artfully.

Art As Pastoral Word

In people's ministry to one another—both lay and clergy pastoral care—art has potential to help them feel their feelings, face death concretely, experience hope, seek meaning, share joy.

I saw this potential realized a few years ago when one of my colleagues lost her infant daughter. It was a sudden, wrenching tragedy. Very shortly after the announcement was made I walked into a classroom where, according to plan, I was to discuss the work of Rubens. Many of the students were weeping, and I was struggling for control. I said to them, "I can't talk about Rubens today. He is too noisy and energetic and rowdy for the way we feel right now." But I had in my carousel several slides of paintings by Velazquez. Looking at them, especially his *Las Meninas*, we were able to see with special clarity how this artist—perhaps through his very faithfulness to his subject—probed the ephemeral nature of reality. Grief had peeled away a layer or two of our protective shells; together we looked at the face of his *Infanta Margarita* and saw not only her royal bearing, her sweetness and beauty, but in her eyes an uncanny beyond-her-years wisdom that one student likened to a particular type of Greek icon in which Mary weeps over her infant Jesus, foreseeing his agony and death.

Art can disturb, open old wounds, bring us to the edge of the void. Many times I have witnessed cascading emotion from individuals who, following the artist's trail, have been drawn into the deep dark woods of their own repressed fear or loneliness. I could only offer mute understanding, and wonder at the artwork's power to evoke such carefully buried thoughts and feelings.

Art can also heal.

It would be presumptuous to begin constructing hypothetical techniques for the use of art in the course of a counseling session. Certainly there are possibilities for incorporating contemporary artworks in such therapeutic techniques as imaging

and reframing.[6] The reader is left to reflect on potential uses of art in a ministry of healing.

Art As a Contagion

It is not hard to imagine art's usefulness in our care for each other, for the experience of art generalizes to many corners of our experience. The descriptive powers honed in observing the minute details of a complex painting such as *Las Meninas* generalize; we may use the same skills to bring abstract theological concepts to bear on our day-to-day lives.

As our forays into art criticism teach us to recognize and acknowledge the limitations of personal taste and cultural bias, our openness spreads; we are better able to suspend our frame of reference in a variety of new situations and truly hear another's point of view.

The meditative stillness that envelops us as we stand before a panel by Mark Rothko permeates our awareness; we discover the Spirit's voice in that silence.

As we face the fear of death or madness or intimacy in a painting by Edvard Munch, the experience engulfs our own fears; we confront them, and thus are able to deal with them in light of our faith.

As works like Abakanowicz's *Backs* provide an alternative to emptiness, to dread, to the objectification of ourselves and others, new views open out before us; we see ourselves as members of a redeemed community.

As art reminds us of our humanity, oneness unfolds; we reach out to another in communion. As art allows us to appreciate deep, absurd, extravagant joy, we are enlarged; joy (but not necessarily pleasure) becomes ours, a gift of faith and art that no one can take away from us.

As we learn to experience art in its many tensions, our insight expands; we understand that most of what is important in our lives is paradox, part of the wholeness of existence, not a puzzle to be solved but a mystery to be embraced.

As we persevere in our relationship with a difficult work of art, our persistence is reinforced; we reap the rewards of difficulty and struggle and may be able to face other problems with graceful determination.

As we interpret artworks of the past, history at once broadens and personalizes; we enter into our own past and gain new meaning for our present and our future.

As we struggle to understand artworks of the present, illumination spreads, clarifies, reveals; we wrestle with the anxieties and needs of our own time and may see that the artist's struggles are our own, that the difficulties and joys we face are shared by others.

> As we fall silent
> as we share another's vision
> and make it ours
> as we look and look and look
> as we seek
> we are apprehended.
>
> It is a kind of prayer.

Notes

In citing works in the notes, short titles have been used for repeated references.

Foreword

1. *Gravity and Grace*, translated by Arthur Willis (New York, G. P. Putnam's Sons, 1952), 52.

Preface

1. Tom Wolfe, *The Painted Word* (New York: Farrar, Straus, & Giroux, 1975).

Chapter One: Sight and Spirit

1. Mark Rothko, quoted in *Twentieth Century Artists on Art*, Dore Ashton, ed. (New York: Pantheon, 1986), 248.
2. Michael Tracy, quoted in *Off the Wall*, exhibition catalog (San Antonio: San Antonio Museum of Art, 1981), last page.
3. Flannery O'Conner, Preface to *Wise Blood,* in *Three by Flannery O'Conner* (New York: Signet Books, 1962), 8.
4. Robert W. Jenson, *Visible Words* (Philadelphia: Fortress Press, 1978), 18.
5. St. Augustine, quoted in ibid., 3.
6. Martin Luther, *Luther's Works*, vol. 36 (Philadelphia and St. Louis: Muhlenberg and Concordia, 1969), 135–136.
7. Geoffrey Wainwright, "Christian Spirituality," *The Encyclopedia of Religion*, vol. 3, edited by Mircea Eliade (New York: Macmillan Publishing Co., 1987), 452.
8. Edmund Burke Feldman, *Varieties of Visual Experience* (New York: Abrams, 1987), 31.
9. Marcel Duchamp, quoted in Duane and Sarah Preble, *Artforms* (New York: Harper & Row, 1985), 40.
10. Georgia O'Keeffe, *Georgia O'Keeffe* (New York: Viking Press, 1976), no page numbers in book.
11. Mark Rothko, quoted in *Twentieth Century*, 247.
12. Abby Aldrich Rockefeller, in a 1928 letter to Nelson A. Rockefeller, quoted in Marion Oettinger, Jr., *Folk Treasures of Mexico* (New York: Abrams, 1990), 37.

13. Paul Klée, quoted in Preble, *Artforms*, 377.

14. Pablo Picasso, quoted in Preble, 234.

15. John Perreault, "Beyond Belief: On the Spiritual in Art", in *A Sense of Spirit*, edited by Jana Vander Lee (Houston: University of Houston, 1983), 18.

16. Dominique de Menil, quoted in Jane and John Dillenberger, *Perceptions of the Spirit in Twentieth-Century American Art* (Indianapolis: Indianapolis Museum of Art, 1977), 110.

Chapter Two: Forming Spirit

1. John W. Dixon, Jr., *Images of Truth: Religion and the Art of Seeing* (Atlanta: Scholars Press, 1996), 18.

2. Ernest Hemingway, "A Clean, Well-Lighted Place," *The Complete Short Stories of Ernest Hemingway* (New York: Charles Scribner's Sons/Macmillan Publishing Company, 1987), 291.

3. Discussion of the parallels between art and religion is outside the scope of this book; the reader is referred to Simon Laeuchli, *The Conflict between Religion and Art* (Minneapolis: Fortress Press, 1980).

4. Also see Laeuchli, above, for a discussion of reenactment.

3. Ira Progoff, *The Symbolic and the Real* (New York: Julian Press, 1963), 292.

6. Duchamp, quoted in Preble, *Artforms*, 40.

Chapter Three: Art's Intent

1. Paul Klée, in *The Thinking Eye: Paul Klée Notebooks*, edited by Jurg Spiller, translated by Ralph Mannheim (New York: George Wittenborn, Inc., 1960), 96.

2. Frank Burch Brown, *Religious Aesthetics* (New York: New York University Press, 1992), 86.

3. For the development of these categories I am indebted to Frank Burch Brown's *Religious Aesthetics*.

4. Jene Highsten, quoted in *Walker Art Center: Painting and Sculpture from the Collection* (New York: Rizzoli, 1990), 341.

5. Burch Brown, *Religious Aesthetics*, 88.

6. See Dixon, *Art and the Theological Imagination* (New York: The Seabury Press, 1978), 12–13.

7. John Berger, *Ways of Seeing* (London: Penguin, 1972), 9.

8. Isamu Noguchi, quoted in *Twentieth Century*, 241 (emphasis added).

9. Kasimir Malevich, quoted in *Modern Artists on Art,* edited by Robert L. Herbert (Inglewood Cliffs, N.J.: Prentice-Hall, 1964), 38.

10. Berger, *Ways of Seeing*, 7.

Chapter 4: Seeing Whole

1. See Laeuchli, *Conflict*, 20-31.

2. Picasso, quoted in *Twentieth Century*, 5.

3. Charles Demuth, quoted in ibid., 101.

Chapter Five: At First Glance

1. John Irving, *The Hotel New Hampshire* (New York: Dutton, 1981), phrase repeated throughout book.
2. John Russell, *The Meanings of Modern Art* (New York: Harper & Row, 1981), 13.
3. An interview with Sister Wendy Beckett as posted on the Web site of the Public Broadcasting Service. Copyright © Sister Wendy Beckett. Used by permission.
4. Franz Marc, quoted in *Walker Art Center*, 341.
5. See Feldman, *Varieties*, 490.
6. Kate Nelson, unpublished student essay, c. 1990. Used with permission.
7. Thomas Eakins, quoted in Gordon Hendricks, *The Life and Works of Thomas Eakins* (New York: Grossman, 1974), 57–58.
8. Museum of Modern Art, New York.

Chapter Six: Looking At, Looking Around

1. Ed Kienholz, quoted in *Twentieth Century*, 224.
2. Matisse, quoted in Preble, *Artforms*, 39.
3. Arnold Toynbee, "Art: Communicative or Esoteric?", *On the Future of Art* (New York: Viking Press, 1970), 9–15.
4. O'Keeffe, quoted in *Twentieth Century*, 42.
5. Francis Bacon, quoted in ibid., 139.
6. Anonymous (unsigned) student essay.
7. Henry Moore, quoted in *Twentieth Century*, 73.
8. For this concept I am indebted to Duane and Sara Preble, *Art Forms* (New York: Harper & Row, 1985).
9. Margaret Atwood, *Cat's Eye* (New York: Doubleday, 1988), 1.
10. Dixon, *Art and the Theological Imagination*, 83.

Chapter Seven: Looking In, Looking Beyond

1. Kimio Tsuchiya, quoted in Howard N. Fox, *A Primal Spirit: Ten Contemporary Japanese Sculptors* (Los Angeles: Los Angeles County Museum of Art and New York: Harry N. Abrams, 1990), 110.
2. Feldman, *Varieties*, 478.
3. Ibid., 478–479.
4. Tim O'Brien, *In the Lake of the Woods* (New York: Houghton Mifflin Co., 1994).
5. John Russell, *The Meanings of Modern Art* (New York: Harper & Row, 1981), 27.

Chapter Eight: Art As Prophetic Word

1. From "The Wasteland" by T. S. Eliot, in *Complete Poems, 1909-1962* (London: Faber and Faber Ltd), 53. Used by permission.
2. Francis Picabia, quoted in *Twentieth Century*, 24.
3. For many of the ideas presented in this chapter, I am indebted to Walter Brueggemann, *The Prophetic Imagination* (Philadelphia: Fortress Press,

1983; second edition, Minneapolis: Fortress Press, 2001).

4. Ibid.

5. Some details have been changed to disguise the boy's identity.

6. Umberto Boccioni, quoted in Russell, *Meanings*, 149.

7. Toynbee (see ch. 6, n. 3), 14.

8. Feldman, *Varieties*, 190.

9. Anselm Kiefer, quoted in Michael Auping, "Paintings for the Decades: Realism, Memory and Re-Figuration," *Modern Art Museum of Fort Worth Calendar* (July/August/September 1997), 5.

10. Bacon, quoted in *Twentieth Century*, 139.

Chapter Nine: Art Forming Community

1. Charles Champlin, quoted in Preble, *Artforms*, 436.

2. Jenson, *Visible Words*, 12.

3. Albert Pinkham Ryder (1847–1917), as quoted in *The Spiritual in Art* (New York: Abbeville Press and Los Angeles: Los Angeles County Museum of Art, 1986), 114.

4. See Betty Edwards, *Drawing from the Right Side of the Brain* (Los Angeles: J. P. Tarcher, Inc., 1979), and *Drawing on the Artist Within* (New York: Simon & Schuster, Inc, 1986).

5. Most of the projects described above require the commitment of funds for honoraria to professionals from the art community who assist or lead or teach, unless they are members of the congregation.

6. See Howard W. Stone, *Brief Pastoral Counseling* (Minneapolis: Fortress Press, 1994), and Arnold Lazarus, *In The Mind's Eye* (New York: Guilford Press, 1977).

Questions and Activities for Discussion

The following questions may be helpful to groups of people, working with or without a leader, who are sharing their experiences and interpretations of art. They may also be useful for individuals seeking greater richness and depth in their responses to works of art.

These activities can take place in front of the original artwork or using slides or poster-size reproductions of the art. Visit art museums and galleries as a group, and see Further Reading and Resources to find other sources of images.

Questions and ideas to facilitate description

1. *What do you see?* This is a brainstorming exercise. Each group lists every single item that the participants notice in an artwork. Appoint a recorder to keep a list. Do not leave anything out. If the class is large, break into smaller groups of three to five people, then share lists with the larger group. If you are using glossy art posters, give small self-sticking notes to small groups; each person describes details on the notes and places them in the appropriate area of the poster.

2. *Working from the general to the specific.* What are the most general things you can say about this work of art (that could be said of millions of other artworks as well)? What are the next-most general observations (things that could be said of thousands of artworks)? What could only be said of hundreds of

artworks? What could only be said of dozens? A few? What could be said about this artwork alone? Do each level of this exercise separately.

3. *Can you see it?* Working from the general to the specific, write a letter about this work of art to a person who has never seen it. Use concrete and vivid words so that the person reading your description can visualize the artwork. These may be written as "homework" and shared with the group at the next meeting.

To make this into a game:

a. Provide several similar art reproductions to readers of the descriptions. Let the readers try to choose the one that fits the written description.

b. The leader of the group, or a member who is somewhat gifted in drawing, reads each description and attempts to make a simple drawing or diagram of the artwork based on what is written. This activity could be carried out in teams, with no particular winners but an abundance of laughter.

4. *Topical description.* Select a particular element or principle of art, such as light, that seems to be an important part of this artwork. Ask the group to offer detailed observations on this aspect of the work only. In the case of light: Where are the light and dark areas? Where is the light coming from? If there is a noticeable source of light, what does it illuminate? What, if anything, is in the shadows? Create questions that suit the artwork.

5. *Just the facts, please.* Divide a group into teams. Give each team a different art reproduction. Compile descriptive lists that detail only what is seen. Try to avoid interpretation, analysis, or judgment. Exchange lists with other teams; each team tries to ferret out items that are not strict factual description. Tabulation of results is optional, depending on the competitive spirit of the group.

After the description activities, discuss: How did simply observing and describing the artwork change our perceptions of it?

Questions and ideas to facilitate analysis and interpretation

There are many kinds of analysis: formal, historical, psychological, sociological, and political, to name a few. Here the group is a font of information that can contribute to each person's understanding of an artwork. The first two questions below deal specifically with the analysis of form; see chapter 6 for guidance and information on formal analysis. The latter questions seek to draw upon the broad source of knowledge in a varied group.

Thematic analysis will naturally lead to interpretation. However, try at the beginning to keep the discussion to factual information (about the art or related subjects) and discernible visual relationships. The factual analysis will provide a foundation for fruitful interpretations of meaning that are far more than just voicing opinions.

1. *Elements of art.* Using one or more artworks, choose one element of art, such as line, and ask the group to list every possible way that element is used in the artwork. Then discuss how the use of that element affects the total work—for example, diagonal lines producing a feeling of movement, or implied lines drawing the viewer's eye from one part of the composition to another.

2. *Principles of design.* Using the same format as elements of art, above, discuss the art in terms of one or two specific design principles, such as unity. (What specific methods did the artist use to unify the composition? Is the emphasis on unity, or variety?)

3. *What's your line?* Do you have any knowledge, experience or avocation that connects with this artwork? For example, an abstract painting by Helen Frankenthaler appeared to my students like two large shapes cradling or hugging a somewhat smaller shape. They interpreted the work in terms of family. After reading its title, "Alloy," those who had an understanding of metals were able to contribute to our analysis of the shapes and colors. Interestingly, the students used the scientific concept of *alloy* to arrive back at an interpretation of the painting that concerned the individuality and unity that exists within a family.

4. *Themes of faith*. Ask a group to analyze an artwork in terms of a particular spiritual theme. Themes may be drawn from Bible stories, theological constructs, spiritual life, or the church calendar. Be wary of choosing artworks that are topical or obvious. Sometimes the more difficult it is to make a connection, the more fruitful the result.

5. *Psychological themes*. A group facilitator who is a psychologist could certainly enrich group analyses of artworks. Psychological themes might include: anxiety, depression, obsession, the subconscious, and many more.

6. *Other themes for analysis and interpretation*: views of death; people at work and play; family life; loneliness and isolation; community; war; poverty; humor; dreams and fantasies; biblical themes; popular culture; celebration. Other themes may arise out of previous subjects of study if it is an ongoing group.

7. *Compare and contrast*. Choose and display any two artworks that are "alike but different." Have members of the group list similarities and differences, and then discuss any observations that result. When similarities are readily apparent, focusing on the differences sometimes yields more profound insights. Comparing and contrasting is a tool to heighten observation, discover relationships (analysis), and find meanings. If time is short, it is useful to restrict the compare-and-contrast to a specific theme.

The following are a few suggestions of pairs of artworks, reproduced herein, to compare and contrast. Many others would serve as well.

van Gogh, *Potato Eaters*/Picasso, *Guernica*
Connell, *Song from Bistineau*/Stone, B.P. *(After Jackson Pollack)*
Tracy, *Cruz de la Paz Sagrada*/Rothko, *The Rothko Chapel*
Velazquez, *Las Meninas*/Beckmann, *Family Picture*
Ryder, *Death on a Pale Horse*/Picasso, *Guernica*
Goya, *The Men in Sacks*/Abakanowicz, *Backs*
Kiefer, *Quaternity*/Beckmann, *Family Picture*

8. *Connections*. This exercise is similar to comparing and contrasting, but here the group focuses specifically on finding similarities where they are not evident. Looking at two or more artworks that seem very unlike each other (such as van Gogh, *Potato Eaters* and Abakanowicz, *Backs*), try to find as many connections or similarities as possible. This may begin with brainstorming, and end with a discussion of the significance of those discovered connections. A few suggestions of places to look for connections are as follows: visual metaphors (see chapter 6); color, texture, lines, other formal elements of art; design principles such as type of balance, variety, etc.; themes; subject matter; feelings the works communicate; organic or geometric shapes and forms; composition or arrangement; art media used; the artist's attitude toward reality, nature, humanity, religion, war, or other topics; and more.

9. *What does it remind you of?* Images can trigger an infinite number of memories and associations. Ask group members to look at one or two artworks and free-associate (see chapter 7). They may find literary associations. They may come up visual metaphors (the clouds in the painting look like elephants), personal memories, places they have been, other artworks, events in the news—anything at all. Some of these associations will be meaningless; it is up to the facilitator to draw the discussion along the more promising avenues.

General discussion questions

1. Is it art? What makes something an artwork, not just a well made or pleasing object? (See chapter 3).

2. What are the parallels between art and religion? In what ways is each unique? Is there a conflict between art and religion? (See chapter 2.)

3. What is it about art that makes people mad when they don't understand it?

4. What is the nature of reality? How does art express or take part in different levels of reality? Find examples.

Finally, any chapter or section of the book may be useful as a source for topics of group discussion, and the flow of conversation may suggest new paths to explore.

Follow the trail.

101 Questions to Ask of an Artwork

This is not an assignment. The questions that follow are suggestions for viewers who are "stuck" in front of an artwork, unsure of how they should begin. You surely will not need to go through the entire list for each artwork you consider. Once you become comfortable with the questioning technique of art criticism, you will think of many more (and more interesting) questions to ask.

1. What is it? (Painting, sculpture, assemblage, collage, print, garment, etc.)
2. Who is the artist and when did she/he live? (Is the artist still alive?)
3. What is the artist's nationality?
4. What do I know about the artist's life?
5. When and where was it made?
6. What title would I give it?
7. What is the actual title?
8. What size is it?
9. Is it two-dimensional or three-dimensional?
10. If it is three-dimensional, is it in the round or a relief sculpture?
11. If it is relief sculpture, is it high relief (deep) or low relief (shallow)?
12. What is its actual or approximate overall shape? (Rectangle, oval, cube, etc.)

13. What is the medium? (Oil paint, watercolor, wood, fabric, paper, ceramic, wax, etc.)
14. How was it made? (Carved, nailed, brushed, glued, molded, sewn, welded, etc.)
15. Is it fancy or plain? (Elaborate.)
16. What might be its purpose? (Expressive, decorative, functional, didactic, etc.)
17. If it has a function, what is it? (Ritual object, garment, shelter, container, etc.)
18. Do I recognize any images? If so, what? (List them all.)
19. Are the images from the natural or human-made environment? How do I know?
20. Is the artwork "readable"? (Even if abstract, is it hard or easy to see what's what?)
21. Do I see any dots in the artwork?
22. If I cover up the dot(s), does the artwork look very different?
23. Are dots used to attract the eye, to direct the eye, as pattern, or decoration?
24. What kinds of lines do I see? (Straight/curved/angled; horizontal/vertical/diagonal?)
25. How are lines used? (Edges, details, to create darks and lights, show movement, etc.)
26. What line qualities are used? (Squiggly, fuzzy, thin, bold, nervous, light, dark, etc.)
27. Do any marks look somewhat like handwriting?
28. Does it look like the artist worked quickly, deliberately, or slowly?
29. What shapes do I see in the artwork?
30. What kinds of shapes? (Geometric, organic, curved, angular, smooth, jagged, complex, simple, etc.)
31. Does the artwork look mostly geometric or mostly organic?
32. What shapes are repeated?
33. What is the main thrust of the artwork? (Horizontal, vertical, diagonal)

34. What kind of movement does it suggest? (Speed, frenzy, rhythm, stillness, etc.)
35. Are there any patterns in or on the artwork? What are they?
36. Is the artwork dark, light, or somewhere in-between?
37. Are there shadows?
38. Is there high or low contrast between dark and light?
39. If there is a light source, where is it coming from?
40. What is the quality of the light? (Diffused, direct, soft, harsh, warm, cold, etc.)
41. Did the artist use color? If so, what are the colors?
42. Are the colors bright, neutral, intense, clashing, harmonious?
43. Are they warm or cool colors?
44. What does the color remind me of, or what feeling does it give me? (What other images can I think of that are that color?)
45. Is it a beautiful color?
46. Do I feel like touching the artwork?
47. What is the overall texture? (Rough, grooved, scratchy, smooth, hard, soft, etc.)
48. How many different textures can I see or feel?
49. How does the texture influence the overall "feel" of the artwork?
50. Is the work crudely or finely made, or some of both?
51. Is the artist's hand evident? (Brushstrokes, chisel marks, fingerprints, paint drips, etc.)
52. Do these marks of the artist's hand look accidental, incidental, or deliberate?
53. Does the craftsmanship (whether it is highly crafted or sloppy in appearance) contribute to or detract from my experience of the work?
54. Does everything look clear and focused (linear) or soft and blurry (painterly)?
55. If the artwork is two-dimensional, does it give the illusion of a deeper space? How deep?

56. Do the near shapes overlap the far shapes? Are they bigger? Brighter? More focused? Darker or lighter?

57. Do I think the illusion of depth is deliberate, incidental (relatively unimportant), or accidental?

58. Is the artist deliberately distorting or confusing the spatial illusion?

59. How many viewpoints are used?

60. Does the artwork look unified?

61. What helps to make it unified? Varied?

62. Are any images repeated several times? What are these motifs?

63. How many different images can you see in the artwork?

64. Are there any visual metaphors in the artwork?

65. Does each visual metaphor look like something in or outside of the artwork?

66. If the artwork is flat, what do I notice about the surface?

67. How is the artwork divided up? Are the divisions obvious, or subtle?

68. Does everything in the artwork look equally important? If not, what draws the eye?

69. Where are the important images placed? (Center, bottom, sides, upper right third, etc.)

70. Are there any triangles in the artwork? How many? Big or small?

71. Are there any images or shapes arranged in a triangle?

72. Do the images in the triangle seem to be important to the artwork?

73. Is the artwork formally or informally balanced? (Symmetrical or asymmetrical?)

74. Is there a central image or shape? What is it?

75. Are there two opposing images (along a central axis)?

76. How do the two opposing images relate to each other? Are they mirror images or not?

77. If the artwork is symmetrical, where is the line of symmetry?

78. If it has radial symmetry, what is at the center?

79. If the artwork is asymmetrical, how are opposite sides or corners balanced? (For example, does the visual weight of a bright color balance the visual weight of a large, solid shape?)
80. Are there people in the artwork?
81. Are they "types" or do they look like real people?
82. Are they rich or poor? Powerful or weak? Interesting or dull? Funny or serious?
83. Would I like to meet them?
84. Do they remind me of anyone I know?
85. What names would I give them?
86. What are they doing?
87. Are the people painted expressively or realistically?
88. What does the artist want me to think/feel about the people in this artwork?
89. Is the artwork abstract?
90. What are some possible sources of the abstract imagery?
91. Is it totally abstract (unrecognizable) or only somewhat abstract (distorted, simplified, or changed in some other way)?
92. Is there a story the artist seems to be telling?
93. Is it a known story, such as a myth or historical event, or is it up to the viewer to figure it out?
94. What does this artwork seem to tell me about the subject?
95. What does it seem to tell me about the artist?
96. What story could I make up about this artwork?
97. If I had made this artwork, how would I explain it to others?
98. What meanings might the artist have intended?
99. What does it mean to me?
100. Is it art?
101. Is it good art?

Further Reading and Resources

The following list offers only a very few of the many excellent printed works that can enrich the reader's apprehension of art's spiritual import. They are arranged in loose categories (somewhat overlapping, as is the nature of the enterprise), followed by a convenient resource for obtaining useful visual aids for teaching and group discussion.

The list is far from exhaustive, and readers are encouraged to do research on their own, find books on art that speak to their own hearts, and be inventive about obtaining visual materials to aid their learning and/or guiding enterprise.

A few of these works are out of print, but copies should be available in libraries or through used bookstores.

General books on art, artists, and art appreciation

The Art Book. London: Phaidon Press Ltd., 1996. Available in hardcover and in a handy little paperback, *The Art Book* is a guide to five hundred major artists. Each page features a brief biography and one color image representative of each artist's work.

Ashton, Dore, ed. *Twentieth Century Artists on Art*. New York: Pantheon, 1986. This volume contains an abundance of quotations by well-known artists of the century now ending.

Berger, John. *Ways of Seeing*. London: Penguin, 1972. A short, easy to understand book on art criticism.

Edwards, Betty. *Drawing from the Right Side of the Brain*. Los Angeles: J. P. Tarcher, Inc., 1979.

_____. *Drawing on the Artist Within*. New York: Simon & Schuster, Inc, 1986.

Feldman, Edmund Burke. *Varieties of Visual Experience*. New York: Abrams, 1987. Feldman developed the definitive art-critical method upon which the present work and many others are based. *Varieties* is lavishly illustrated and arranged by theme, making it very useful for groups of people who wish to learn about art holistically rather than chronologically. Highly recommended.

Fox, Howard N. *A Primal Spirit: Ten Contemporary Japanese Sculptors.* Los Angeles: Los Angeles County Museum of Art and New York: Harry N. Abrams, 1990.

Gilbert, Rita and William McCarter. *Living with Art.* New York: Alfred A. Knopf, Inc., 1988. A general art appreciation book with sections on art themes, art vocabulary, art media, and art history. Includes forty-five one-page biographies of prominent artists and "art people." The book is easy to read and generously illustrated with artworks from all periods of history.

Hunter, Sam and John Jacobus. *Modern Art.* Englewood Cliffs, N. J.: Prentice-Hall, Inc., 1985.

Los Angeles County Museum of Art. *The Spiritual in Art: Abstract Painting 1890-1985.* New York: Abbeville Press, 1986. This oversize volume with more than five hundred illustrations is a rethinking of the abstract art movement in the twentieth century, illuminating not only the art but also the spiritual beliefs that nourished it.

O'Keeffe, Georgia. *Georgia O'Keeffe.* New York: Penguin, 1976. There are many O'Keeffe books on the market; this one is her own answer to the "strange things people have done with my work." It is full of beautiful pictures, childhood memories, and stories about her life and art.

Preble, Duane and Sarah. *Artforms.* New York: Harper & Row, 1985. This superior general-purpose art appreciation book is thoroughly researched, yet readable and user friendly. It includes sections on art principles and themes, art media, and art through history. The end material contains a handy time line, pronunciation guide, and extensive bibliography.

Russell, John. *The Meanings of Modern Art.* New York: Harper & Row, 1981. Russell based this book on the beliefs that "in art, as in the sciences, ours is one of the big centuries," and "the history of art, if properly set out, is the history of everything" (p. 9). His work offers a deep and broad understanding of modern art up to 1980.

Updike, John. *Just Looking: Essays on Art.* New York: Alfred A. Knopf, 1989. Crystalline descriptions and unabashedly personal responses to an eclectic array of artworks by one of the great writers of our time.

Woodford, Susan. *Looking at Pictures.* Cambridge: Cambridge University Press, 1983. A very small and easy-to-read volume that offers good advice for ways of looking at and thinking about art.

The arts and religion; religious aesthetics

Adams, James Luther and Wilson Yates, eds. *The Grotesque in Art and Literature: Theological Reflections.* Grand Rapids, Mich.: William B. Eerdmans Publishing Company, 1997. See especially chapters by Wilson Yates and Roger Hazelton.

Bruggeman, Walter. *The Prophetic Imagination.* Philadelphia: Fortress Press, 1983. Second edition, Minneapolis: Fortress Press, 2001.

Burch Brown, Frank. *Good Taste, Bad Taste, & Christian Taste: Aesthetics in Religious Life.* Oxford: Oxford University Press, 2000.

_____. *Religious Aesthetics*. New York: New York University Press, 1992.

Dillenberger, Jane. *Image and Spirit in Sacred and Secular Art*. New York: Crossroad/Herder & Herder, 1990.

Dillenberger, Jane and John. *Perceptions of the Spirit in Twentieth-Century American Art*. Indianapolis: Indianapolis Museum of Art, 1977.

Dillenberger, John. *A Theology of Artistic Sensibilities:The Visual Arts and the Church*. London: SCM Press, 1987.

Dixon, John W., Jr. *Art and the Theological Imagination*. New York: The Seabury Press, 1978.

Hazelton, Roger. *Ascending Flame, Descending Dove: An Essay on Creative Transcendence*. Philadelphia: The Westminster Press, 1975.

_____. *A Theological Approach to Art*. Nashville and New York: Abingdon Press, 1967.

Kung, Hans. *Art and the Question of Meaning*. New York: Crossroads, 1981.

Laeuchli, Simon. *The Conflict between Religion and Art*. Minneapolis: Fortress Press, 1980.

Wolterstorff, Nicholas. *Art in Action: Toward a Christian Aesthetic*. Grand Rapids, Mich.: William B. Eerdmans Publishing Company, 1980.

Visual resources

There is almost no limit to the numbers of visual art resources that will aid in the quest for a more meaningful interpretation of art. Art museums and galleries, of course, are primary because there you stand face to face with the actual work of art. Other resources include books (look at the sale tables of major booksellers for reduced art books), slides, videos, posters, and CD-Roms. I list the following source only as a convenience; there are many places from which to obtain the materials it provides, and I have no connection with this particular vendor or reason to recommend it over any other.

Crystal Productions Art Education Resources Catalog. Crystal Productions, Box 2159, Glenview, IL 60025-6159, E-mail custserv@crystalproductions.com, telephone 800-255-8629. A single source for a wide variety of visual aids related to art, this catalog offers slides, posters, videos, software, and books.

Take 5 Art Prints. Crystal Productions. When a trip to the art museum is not possible, art prints or posters may be preferable to slides because it is not necessary to darken the room, and posters can be sorted and spread on tables as well as displayed in front of a group. As a result, they are very useful for small group discussion activities. Each portfolio in the *Take 5* series contains five large, laminated reproductions of works by major artists. The back side of each print contains background information, discussion questions, and guided analysis. Each portfolio also includes a separate teacher's guide. The following sets are available (brief titles): The Artist as Storyteller; Art and Mathematics; Art and Social Studies; Printmaking; Urban Environments;

Still Lifes; Collage and Assemblage; Sculpture; Women Artists; Drawing; Children; Horses; People at Play; People at Work; Landscapes; Cityscapes; Abstract Art; Nonobjective Art.

Multicultural Art Print Series. Crystal Productions. Co-published by The Getty Education Institute for the Arts and the J. Paul Getty Museum. Similar to the *Take 5 Prints*, the following sets of five posters with background information and teacher's guide are available: Women Artists of the Americas; Arts of India; Mexican American Art; Selected American Indian Artifacts; African American Art; Pacific Asian Art.

Glossary of Terms

abstract expressionism A style of painting originating in the late 1940s that conveys feelings through a bold and free application of paint and abstract imagery, sometimes called action painting.

abstraction The alteration of natural appearances in some important way, for example, unnatural color or distortion, usually to emphasize a certain quality, emotion, or idea; the image resulting from this change.

additive methods Building up or adding materials and/or objects to make an artwork, for example, painting, welding.

aesthetic Referring to heightened sensory awareness or perception; the opposite of anesthetic.

aesthetics The study of sensory perception and especially beauty.

afterimage A visual image lingering on the retina for a number of seconds after one looks away from the original sight. Appears as a negative of the real image; for example, white becomes black, orange becomes blue, etc.

anesthetic A dulling or loss of sensory awareness or consciousness.

arrangement The conscious placement of various elements and images in an artwork.

art criticism Looking at and talking about art; includes response, description, analysis, interpretation, and judgment, not necessarily in that order.

artwork The product of an artist, made with intent, knowledge and/or skill, and aesthetic intent or effect.

assemblage Sculpture made by putting together various found or constructed objects.

asymmetrical Without symmetry.

atelier Workshop; artist's studio.

balance Relates to the relative visual weight of the components of an artwork.

baroque A style of seventeenth century art characterized by complex curves, extremes of action and emotion, grandeur, and high contrast between dark and light.

brushstroke Mark made by the movement of a brush loaded with liquid medium.

Byzantine art A style of fifth century and later art from the Byzantine empire; in painting, characterized by formal balance, rich color and gold leaf, religious imagery and portraiture, and intricate decoration.

calligraphy The art of beautiful handwriting. In a broader sense, calligraphic refers to marks that resemble handwriting.

carving The use of a sharp tool to remove material from a sculpture, printing block, etc.

casting The use of a mold (negative form), filled with liquid such as plaster, glass, or molten metal that subsequently hardens into the corresponding positive form.

chiaroscuro The smooth blending of darks and lights in two-dimensional artworks to create an illusion of three-dimensionality.

classical Referring to the style of Greek art and architecture in the fifth century B.C., and to subsequent art and architecture that shows the influence of that period. Broadly, refers to harmonious and balanced design, tradition, and/or excellence.

closed form Any form or shape that is self-contained, does not have negative space or extend into space, for example, a solid circle or rectangle, a monolith.

cold light Light with a pure white, bluish or violet cast, imparting a feeling of coolness.

collage Artwork made by assembling and gluing together various two-dimensional materials, sometimes in conjunction with drawing or painting.

color field painting Two-dimensional artworks with all-over textural, calligraphic marks and no distinct shapes or spatial illusion.

color intensity The relative purity (brightness or dullness) of a color.

color scheme The plan or choices of colors for an artwork.

color temperature The warm or cool properties of colors.

complex Made up of various qualities, for example, a single line that is in turn straight, curved, angled, diagonal, vertical, and horizontal.

commemorative Images that document or celebrate important events or people, for example, a wedding photograph.

composition The organized arrangement of visual elements in a given space.

conceptual art Art in which an idea is more important than a product, often documented by photographs, writing, or technological means.

content The idea, message, meaning, or spiritual essence of an artwork.

contours Edges; lines that represent edges.

contrast Marked differences in visual elements; for example, a high contrast photograph has extremes of dark and light, with relatively few in-between tones.

cool colors Colors containing blue: violet, blue-violet, blue, blue-green, green.

craft The care and skill that goes into the making of an object.

cubism Extraordinarily influential and revolutionary art movement begun around 1907 by Picasso and Braque, who held that the fixed viewpoint is not the way people actually see; characterized by multiple viewpoints, fragmentation and geometric reconstruction of imagery, and an ambiguous space.

curator A person entrusted with the care of artworks; museum curators often also organize exhibitions and administer educational programs.

dada Iconoclastic, anarchist, sometimes humorous art (or anti-art) movement begun in the 1920s in Switzerland but still very much in evidence today. Early dadaists included Man Ray, Duchamp, Oppenheim, among others.

decorative With intent to please the eye or enhance the appearance of an object or surface.

depth Three-dimensional space, or the illusion of three-dimensional space. Broadly, depth may refer to inner meanings, complexity, spirituality, or essence.

description In art criticism, the act of carefully observing and listing the physical characteristics of an artwork.

design The deliberate organization of visual elements into an object or artwork.

didactic With intent to teach or persuade.

distortion The altering of proportions in visual representation.

documentary With the purpose of marking and/or celebrating a person or event, for example, the Vietnam Memorial, a statue of Lord Nelson.

eclectic Using a wide variety of art styles and techniques.

elements of design The basic parts of an artwork: dot, line, shape, form, texture, value, color, space.

elimination In art-making, leaving out extraneous images and marks.

embodiment The physical manifestation of a spiritual being or truth.

emphasis The use of contrast, color, or other methods to stress a particular image or area in an art composition.

expressionism The act of conveying feelings or sensations through art; style or period of art that focused on the expression of emotion, characterized by spontaneity.

expressive Having an emphasis on content or feeling rather than realistic representation.

eye level The viewer's line of vision when looking parallel to the ground; corresponds to the horizon line.

facade The front surface of a building.

focal point An image or area in an artwork that attracts the viewer's eye.

folk art Works created by people who have not been formally trained as artists.

foreground The images in an artwork that are, or appear to be, in front or close to the viewer.

form The physical attributes of an artwork; sometimes also refers to three-dimensional shape.

formal analysis Examination of an artwork's physical properties and the relationships of its component parts.

formal balance See symmetry.

formalism A style of art in which the art form itself is the subject rather than any outside subject or meaning; almost always nonobjective.

format The size, shape, and orientation of an artwork, for example, an 80 cm. x 112 cm. horizontal rectangular canvas.

found object Pre-existing object or fragment appropriated for use in an artwork, especially in assemblage or collage.

fresco The technique of painting on fresh plaster. The pigment is absorbed into the damp surface and therefore is as permanent as the plaster itself.

frontal Facing the subject directly, usually without a view of its sides. The frontal view of a symmetrical object (such as a face) is symmetrical.

functional Having some real use or capacity.

futurist Referring to an art movement in Italy, beginning in 1909, marked by dynamism, rejection of tradition, and glorification of progress and the machine.

geometric Related to mathematical shapes and proportions, usually having straight edges or regular arcs; rectilinear.

gestural In a free and loose style, applied quickly and/or spontaneously.

gothic Characterized by pointed arches, soaring ceilings, and other features of twelfth through fifteenth century western European architecture.

hard edge Sharp in focus, with clear edges and flat rather than illusionistic; often painted with aids such as rulers or tape.

harmony A unified and peaceful relationship between an artwork's component parts.

Hellenistic Style of Greek art, third to first century B.C., characterized by extreme realism, dramatic action, and emotion.

hermeneutic Referring to the task of interpretation.

hierarchic proportion Size relationships between images (usually human figures) established according to importance rather than actual proportion; for example, an Egyptian pharaoh depicted as twice the size of his servant.

horizon line The place where the earth appears to meet the sky.

hue A specific, named color.

icon An image used as an aid in worship, often depicting the Christ or a saint, sometimes painted on a wood panel.

iconoclasm Literally, "smashing images." The belief that icons are idolatrous and should be destroyed. Also used metaphorically to indicate an irreverent attitude toward tradition; see dada.

illusion A misleading appearance of reality; see also spatial illusion.

illustration The picturing of a story or event.

image Broadly, anything that is seen; sometimes refers to the representation of a human face or a reproduced sight (for example, mirror image).

imitative (of nature) Representing or copying any preexisting form.

impressionist Style of art, started in France around 1870, that conveys a fleeting impression of a scene rather than its realistic details; often features the momentary effects of light and color on a scene.

intensity See color intensity.

interpretation The art-critical task of finding meaning in perceived form.

judgment In art criticism, the task of forming conclusions about an artwork's effectiveness or quality.

kiln Oven used for baking ceramic clay at extremely high temperatures.

line The path made by a moving point; contour. Lines lend definition, direction, movement, and emphasis to artworks.

linear perspective A method developed in the Renaissance that uses horizon line, one or more vanishing points, and working lines to draw geometric forms with the illusion of three-dimensional space.

linear technique Clear, smooth, sharp in focus, sometimes outlined.

liturgical Referring to traditional rites of religious worship.

location Vertical placement of images on a two-dimensional surface or picture plane.

Logos Greek, meaning divine wisdom, the principle that controls the universe.

manuscript illumination The art of illustrating and decorating hand-lettered books, commonly done by monks in the middle ages before the advent of the printing press.

massive Having three-dimensional form.

medium The physical material used to make artworks, for example, oil, charcoal, granite, photography; the plural may be media or mediums.

minimal Reduced to the smallest number of possible elements. Minimal artworks are almost always nonobjective and very spare, with an emphasis on unity rather than variety.

mosaic Art technique that uses tesserae (small tiles, glass, beads, or stones) to create the image.

motif Any line, shape, or image in an artwork that is repeated for pattern or emphasis.

mural Large-scale painting or mosaic on a wall.

mystical Having inner spiritual meaning or reality; relating to one's direct relationship with the absolute.

narrative Referring to story, whether fictional or true. Narrative artworks usually suggest, rather than tell, a story.

naturalism Style of depicting images as they appear in reality.

nature Any preexisting form used as a subject for art.

negative shape or space The shape of the space between, inside, or around objects; see also positive shape.

neutral colors Colors that have been mixed with black or a complementary color to reduce their intensity.

nonobjective Artworks having no reference to nature or any preexisting form.

nonrepresentational See nonobjective.

ontic Of or relating to real, physical (concrete) being or existence.

ontological Philosophical/theological term referring to the nature and source of being or existence.

organic Resembling living forms; curvilinear.

open form Shape or form that extends into space, for example, a five-pointed star or a person with arms spread out to the sky. See closed form.

painterly technique Characterized by loose application of paint, soft and sometimes blurred edges.

pattern The repetition of lines, shapes, or motifs in a regular series or overall design.

performance art Artwork that consists of a dramatization by an artist before an audience, to be distinguished from theatrical performances by actors or entertainers.

perspective Viewpoint; also see linear perspective.

photorealistic A painting style that has its source in photographic images; tends to be sharp in focus and often depicts highly complex reflective surfaces.

picture plane The actual surface of a two-dimensional artwork.

pigment The physical "stuff" of color, for example, pulverized burned bone (black pigment).

plastic arts Any of the visual arts characterized by shaping, modeling, or physically manipulating materials, for example, painting, printmaking sculpture.

point of view In illusionistic artworks, the place from which the artist/viewer surveys the scene.

portrait A picture of a particular person.

positive shape The shape of an object in the artwork (see negative shape).

principles of design Standards or guidelines used in the design of an artwork: emphasis, unity, variety, balance, proportion, pattern, rhythm.

print An artwork that is transferred from one surface (the plate, block, or screen) to another surface, usually paper. Most prints are made in multiples, signed and numbered by the artist.

prophetic Expressive of divine will, often, calling a people to task for their deviation from God's purpose.

proportion The relationship between the sizes of component parts.

realism Representational depiction of subjects as they appear in life; in the nineteenth century, a focus on the real life of ordinary people rather than classical ideals.

realistic Closely resembling the depicted subject.

recede Appear to go back in space.

relief sculpture Sculpture in which three-dimensional elements project from only one side of the artwork; the back is flat and usually not seen. The extent of projection ranges from low or bas relief to high relief.

Renaissance Literally, rebirth; fourteenth through sixteenth century revival of learning, classical art, and literature, interest in human endeavors and individuality.

representation Depiction of preexisting forms in art.

reproduction Copy (not necessarily forgery) of an artwork, for example, a poster of van Gogh's *Starry Night*.

romanticism An emotional and sometimes overblown style of art, primarily in early nineteenth-century Europe; frequently nostalgic, intense, and melodramatic. In America, romanticism infused the continent's landscape with potent symbolism.

sacrament A religious act in which the God is manifested through some physical, visual element and action. Specifically, such rituals that were instituted by Christ; Holy Communion.

sacramental Having some characteristics of a sacrament; symbolizing or embodying the presence of God through an infinite variety of images and experiences such as art, music, friendship, nature, or family rituals.

scale Size; sometimes relative size.

shade A color darkened by the addition of black (see tint).

shape A distinct two-dimensional area delimited by an outline or discernible edge.

site-specific art Artwork, usually scupture, created for a particular location.

spatial illusion The appearance of three-dimensionality on a two-dimensional surface.

stained glass Art form using pieces of painted or stained glass joined with lead; primarily used in windows.

stations of the cross Artworks, usually relief sculptures, used in some churches to signify fourteen stopping places on Christ's walk to Golgotha. In Lent and particularly on Good Friday worshippers may process from one station to the next as they liturgically reenact that walk.

still life Artwork representing inanimate objects, usually of a size that could fit on a tabletop.

studio Place where an artist works; atelier.

style A distinctive way of using art media, elements, and images that identifies the artworks with a certain artist, group of artists, or period in art history.

stylized Depicted in a formulaic way, often simplified or exaggerated, as opposed to naturalistic.

subject matter or subject What an artwork depicts or represents. (Sometimes, the subject is the artwork itself.)

subtractive methods Techniques of creating art by removing material, for example,carving, scraping, chiseling.

suprematist Nonobjective, geometric style begun by Malevich around 1913 in which feeling and spirit are were held be supreme over representation.

surface The top or front of anything, having only height and width; also used to mean superficial appearance as opposed to inner meaning.

surrealist Art movement that began in the 1920s, drawing imagery from the subconscious, dreams, and fantasy.

symbol Anything tangible that represents some (usually intangible) thing outside itself. In Tillich's sense, an image that participates in the thing it represents, for example, light as a symbol for knowledge.

symmetrical Equally balanced along a central axis; mirror image. Most living things appear symmetrical from a frontal vantage point.

tactile Referring to the sense of touch. Tactile texture can be felt, independent of sight.

technique Method of applying or manipulating media to create an artwork.

tempera Paint made from natural pigments and binders as egg, glue or milk protein; to be distinguished from manufactured, so-called tempera paints that actually are opaque watercolors.

texture An element of art that relates to the sense of touch, for example, rough, smooth, furry.

theme The underlying content or message of an artwork or body of work.

three-dimensional Having height, width, and depth.

tint A color lightened by the addition of white (see shade).

tone Any gray value; a color neutralized by the addition of gray (see value, shade, tint).

trompe-l'oeil In French, "fool the eye"; two-dimensional artwork done so naturalistically that it appears to be real. Trompe-l'oeil works best when it depicts still life objects occupying a shallow space, for example, objects hanging on a door.

two-dimensional Having height and width but not depth; flat.

unity Oneness; a principle of design concerning the way in which various elements of an artwork fit together as a whole.

value Relative darkness or lightness. Color has value, but value exists independent of color (for example, black, white, and various degrees of gray).

value scale Progression from lightest (white) to darkest (black) value.

vanishing point Spot on the horizon line where parallel horizontal edges appear to converge.

vantage point See point of view.

variety Principle of design; the combining of a number of visual elements

vestments Garments worn by ministers, deacons, priests, etc., during a religious service.

viewfinder Device for framing a selected area of a scene, for example, a camera viewfinder.

visual texture The depiction or illusion of texture on a smooth surface.

volume Three-dimensional interior or enclosed space.

warm colors Colors that suggest warm temperature: red, orange, yellow and related hues.

warm light Light having a yellow, orange, or reddish cast.

God Is Love edited by Brian Doyle
152 pages, 0-8066-4449-4

God Is Love brings together diverse voices of recognized writers on the common ground of spirituality. In this book, more than two dozen writers share a variety of reflections on spiritual life.

A Joy

the Creator.
us to be
in joy.

rave

on a vast
t—through

Marty

de, set out
and eye that
life.

A JO
CHR

OUR HO

DEMCO

Available wherever books are sold.